The Passion

For Horses

And

Artistic Talent

The Passion

For Horses

And

Artistic Talent

An Unrecognized Connection

Robert M. Miller DVM

Cover painting, "Tranquility" provided by world renowned artist, Fred Stone who is featured in this book. Like so many of the other people described in this book, he walked away from a successful, unrelated career in midlife to become a part of the horse world. www.fredstone.com

Please visit this book's companion website: www.thepassionforhorses.com for full color images and links to artists

ISBN 978-0-9844620-0-1

Published by

Robert M. Miller Communications
14415 Donnington Lane
Truckee CA 96161

www.robertmmiller.com
email: info@robertmmiller.com

Cover Design by Silver Moon Graphics www.silvermoongraphics.com

Other Works by Dr. Robert M. Miller

Books

Natural Horsemanship Explained – From Heart to Hands

The Revolution in Horsemanship – Co-authored with Rick Lamb

Understanding the Ancient Secrets of the Horse's Mind

Imprint Training of the Newborn Foal

Most of My Patients Are Animals

Mind Over Miller

Coming summer 2010: *Handling the Equine Patient – A Manual for Veterinary Students & Technicians*

Equine Videos

Understanding Horses

Safer Horsemanship

Early Learning

Control of the Horse

Influencing the Horse's Mind

Coming 2010: *The Causes of Lameness*

Cartoon Books

Am I Getting To Old For This?

The Second Oldest Profession

Ranchin' Ropin' an' Doctorin'

A Midstream Collection

Websites

www.robertmmiller.com

www.rmmcartoons.com

www.thepassionforhorses.com

TABLE OF CONTENTS

Dedication

This is a book dedicated to the many true horse lovers I personally know who are not included in it. You will know who you are if you fit the two requisites documented in this book:

Kindness, an expression of a powerful nurturing instinct,

and

Artistry, in any of its many forms

I could not include all of you; not even my wife, Debby. Her kindness extends to all living things. She has done ceramics, I love her photography and she has done clothing design. She is graceful and lithe on the dance floor. In her mid seventies, she has won the heart of a rather suspicious athletic horse that was never ridden until he was eight years of age.

She is one of you, a true horse lover.

Preface

Until the most recent decades of my life, I never thought of myself as a horse lover. I just enjoyed working with horses. Although I grew up in the city, I worked summers on farms during World War II, much of the time driving draft horses, and, best of all, riding them in bareback at the end of the working day. Gasoline was rationed throughout the war and there was a huge resurgence of working horses. I will never forget how, at fifteen years of age, I drove a team of Percherons each weighing over a ton. Oh, the sense of power and the thrill of their magnificence.

In 1945, at eighteen years of age, I went into the army, and, except for one ride on a rental horse in the Bavarian Alps, I had no contact with horses as a soldier.

I had volunteered for duty with the 10th Mountain Division (because I wanted to work with the army mules and because I wanted to learn to ski). I had been accepted, but, to my disappointment they no longer needed me because the fighting had ended in Europe.

After I came home and started college, I spent all my summers working with horses, and was active in intercollegiate rodeos, but I still never labeled myself as a "horse lover."

During those years I evolved a method of starting colts which was a departure from the usual Western "bronc-busting" methods.

What we called "colts" back then were four, five, or even six years of age that had never been handled by a human being unless it was to be fore-footed, tied down, branded, and castrated (by a cowboy not a veterinarian) without benefit of anesthesia. Instead of "bronc-bustin'," I

round penned these colts and spent perhaps an hour a day with each one for a week or so before I rode them. I was using what today we call "Natural Horsemanship." Because I had no guidance, I fumbled my way until I developed a routine. How can I describe the elation I felt when these terrified colts calmed down, trusted me, and became gentle, and allowed me to ride them without bucking?

At thirty years of age I finished eight and a half years of university schooling, and was a doctor of veterinary medicine. I never again started a colt except for my own horses and mules.

When I was sixty years of age I retired from the successful and profitable practice that I loved in order to join what had become a revolution in horsemanship by writing, teaching, and explaining it.

This book is the third I have done in a series on that subject.

Another decade passed. I was now seventy and, had constant contact with people involved in the revolution. I finally began to understand why I had made the career choices that I had made in my life, and why so many others had decided upon a lifetime involvement with horses. This choice often meant a relatively low income, risk of injury, long working hours, and being subjected to adverse weather conditions.

Similarly, I came to understand why so many people have given up successful unrelated careers in order to work with horses. I also realized why so many others choose the horse as their principal avocation, often spending a fortune on their hobby, usually with little hope of financial return.

We Are Horse Lovers

Why we are horse lovers is the theme of this book. Let me make it clear that not all people who own or handle horses are horse lovers.

Many do it for expediency, or for ego, or because they hope to make money (usually a futile wish).

I have learned that the overwhelming majority of true horse lovers

have two personality characteristics, and frankly I suspect that they are genetic in origin, rather than learned.

The first is <u>Kindness</u>, and I believe this to be an expression of the nurturing instinct.

The second is <u>Artistry</u>.

No two more disparate species exist than the horse and the human. One is the ultimate prey. The other is the consummate predator.

The horse is the ultimate prey animal because, unlike so many prey species which are equipped with horns, like the rhinoceros, the buffalo, wild sheep and goats, etc., the horse's primary defense is flight.

The human being is not only a predatory and partially carnivorous species, but we are also tool users. The club, and eventually the spear, and the knife have been our hunting tools for most of our existence on Earth. The bow and arrow came along only a few thousand years ago, and gunpowder and the nuclear bomb just yesterday. Lacking sharp teeth and claws, we developed these tools along with cunning, communication, and strategy unlike any other predator on Earth. We became the ultimate hunter.

So, for these two species – the ultimate prey and the ultimate hunter – to be able to bond so strongly with such feeling, and to work together intricately, is a great challenge. We are a species that relishes challenge. To achieve, to explore, to learn, to master, to create, to understand, are mankind's greatest virtues.

I did not include anybody in this book that I did not know personally and, obviously, there are infinitely more who belong here that I have omitted. The horse lovers I describe are simply examples. They vary greatly in many ways, but they share the qualities described above: kindness, artistry, and willingness to face challenge.

Introduction

This is the third in a series of books about the revolution in horsemanship which began in the last quarter of the twentieth century and which has now spread all over the world, changing the way humans relate to the equine species forever.

The first book in this series, **The Revolution in Horsemanship**, which I co-authored with Rick Lamb, documented the history of mankind's relationship with equines from prehistoric times right up to the present. Personally, in that book I targeted the persons who owned or handled horses who had not adopted the methods originated by a few cowboys from the Pacific Northwestern United States of America.

Some such horse persons had presumably not heard of the movement, despite its explosive popularity. Others had heard of it, but were disinterested, complacently satisfied with whatever traditional methods they were using. This is common human behavior whenever radical new concepts are introduced. It isn't so much that they fear new ideas as much as apprehension about giving up the old ideas with which they have been comfortable. A large percentage of horse people fit into this category. They are <u>aware</u> of what is happening but are insufficiently motivated to learn and adopt new concepts even when they see that better results are being obtained. They are satisfied with the status quo and often dismiss new ideas as a fad, or assume that the people who are using them successfully have some special unexplained capabilities.

Lastly, there are those, still a numerous percentage of the people who own and work with horses, who are <u>opposed</u> to the revolution. Included are many professional trainers, who often have been very

successful in the industry. They assume that to accept change is to admit defeat. Rather than being open minded and eager to learn something new, they reject concepts which threaten their pride, self esteem, and confidence. It has always been this way historically. Long after aircraft and machine guns had been introduced into modern warfare, armies in the world were still training soldiers how to make cavalry charges brandishing swords.

When I left my successful and profitable veterinary practice in 1987 in order to devote myself full time to encouraging the revolution in horsemanship, best known today as "Natural Horsemanship," by writing about it and lecturing on it, I had a selfish motive. I was hale and active at sixty years of age, but none of us know how long we are going to live. As a medical practitioner, I was well aware of how an unanticipated disease can abruptly and unexpectedly bring life to an end. I wanted to see the revolution in horsemanship succeed while I was still alive. Although I have worked with every conceivable species of animal before and after I became a veterinarian including livestock, house pets, sea mammals and zoo animals, the horse was always of greatest interest to me. As I explain later in this book, the horse is unique among all animals. No other creature born in the wild and deprived of any human contact can, in a matter of hours, be tamed and bonded to a human as quickly as can a captured mature wild mustang. It is this absolutely unique quality that endeared me to horses early in my life, when I worked with such terrified timid flighty animals and converted them within hours to trusting, willing and cooperative friends.

Thus inspired, and with the encouragement and skills of co-author Rick Lamb, *The Revolution in Horsemanship* was published in 2005. (Lyons Press)

Two years later my second book in this series was published. I called it *Natural Horsemanship Explained* (Lyons Press 2007).

In this book I targeted the convert, the believer, the student of Natural Horsemanship and the teachers of it; the increasing number of

clinicians who have revolutionized this ancient technology. In *Natural Horsemanship Explained*, a book I shall refer to frequently in the book you are now reading, I tried to eliminate the mystery. The swift results that are obtainable without coercion, without the use of force, without the infliction of pain are scientifically explainable. Throughout human history, the speed with which truly talented horsemen were able to obtain the cooperation of their subjects was mystifying to observers. Hence, the term "Horse Whisperer." Whispering has nothing to do with the results observed. However, it is human nature to conveniently explain them as "magic", or "witchcraft", or "hypnotism." Often the horsemen were accused of fraud, the accuser suggesting that the horses have been secretly and previously trained, or that they have been drugged.

Those that master the techniques taught by the growing cadre of clinicians who are expert in them, often become proficient yet do not fully understand <u>why</u> they work. The clinicians themselves often do not grasp the scientific basis for their success. For example, all those who utilize Natural Horsemanship know that retreat reassures the horse. If we step back away from the frightened horse, or if an object that the horse is afraid of is moved <u>away</u>, the horse is reassured. Soon, curiosity and confidence replace fear. Why? It is because <u>PREDATORS DO NOT RETREAT</u>. Horses are not afraid of predators! They are afraid of predatory behavior! Unfamiliar things moving <u>toward</u> the horse are interpreted as predatory and the horse's instinctive primary behavior to evade predation is <u>flight</u>.

This is the sort of information I attempted to share in *Natural Horsemanship Explained*.

The above example enables the horse handler to understand how retreating reassures the fearful horse, how our voice, our stance, our posture, our facial expressions, where our eyes are focused, and how we move all contribute to the flight response. It is against human nature to retreat, especially if we are male and more so if we are a young male. We must be <u>taught</u> how to obtain compliance in the horse and trust, and yet maintain its respect. The goal in our relationship should be 100% respect but zero percent fear. What a challenge for this flighty, timid prey creature,

to gain complete trust and respect, devoid of fear. Yet is this not the goal in the most intimate human relationships; between parent and child, husband and wife, teacher and student, employer and employee?

In *Natural Horsemanship Explained* I devoted a chapter to tools. We are a tool using species. We eagerly seize upon tools as a way of implementing our goals. This is overwhelmingly obvious in this age of electronic technology, but it applies as well to horsemanship. So many people observe masters of horsemanship utilizing tools to facilitate communication with horses. They then conclude that the secret to their success lies in these tools. So they buy the halters, the lead ropes, the sticks, the flags, the wands, the whips, the bits, the hackamores, the longe lines, and the spurs. They fail to understand that these tools simply <u>aid</u> in communication with the horse. It is our <u>body language</u> that is our main communication aid, whether we are afoot or astride. Tools simply exaggerate or amplify our body language. For example, clinician Richard Shrake of Sunriver, Oregon encourages the use of body language without the use of any tools. This can be seen in his clinics and demonstrations as well as in some of his videos. Similarly, in my video *Understanding Horses*, (Video Velocity), I change the behavior in four minutes of an eight year old mule that cannot be caught without the use of grain as a bribe, using <u>only</u> body language. It's all a matter of psychology, communicating expertly with body language. The tools are <u>NOT</u> the answer. They merely serve to enhance our body language, extending our reach. They make us less vulnerable to injury by the horse by extending our reach and allowing us to maintain more distance from the horse.

Now, finally, there is this book, devoted not to the horse but to the people who devote their lives to this animal. As a practicing veterinarian my clientele has included individuals fervently devoted to various species. There are dog people, cat people, bird people, snake people and llama people. There are publications unknown to most of us that cater to the devotees of turtles, hawks, alpacas, and pet monkeys. There are people devoted to almost every conceivable creature and, indeed, to specific varieties and specific breeds.

Yet the true horse lovers are unique. They have qualities I have not necessarily seen in other kinds of animal lovers. One reason they are unique is that the horse is unique. I'll address that in a chapter dealing with that quality I mentioned earlier; that this is the only animal which captured in the wild after maturity can, in a matter of hours, be tamed and gentled, made to bond with a human even though it has not been socialized, and which will work for us. Indeed, mature mustangs have been captured, taught to carry a rider, and then ridden past the point of exhaustion until they die. What other creature will do that for us?

Secondly, horses are dangerous. Although timid and fearful and, unlike many other prey species which are formidably armed with horns or tusks, they are completely dependent upon flight as their primary survival behavior. Their size, speed, and physical strength makes them dangerous. An emergency physician in my area told me that motorcycles are the leading cause of patients he is presented with, followed by horses. Automobile accidents were third.

Interestingly many horse lovers are afraid of the horses they own to which they so passionately devote their time, energy, and income. This is especially true in women of middle age and older, and some clinicians devote themselves almost entirely to helping these people overcome their fears.

Before we begin, let's make one thing very clear. Not all people who own horses, use them, or work with them are what I call "horse lovers." Many people involved with horses lack the passion that this book hopes to describe and explain. Some people work with horses because it is expedient to do so. Perhaps they simply see it as a source of income. Or, perhaps they grew up in the business and found it convenient to carry on.

There are people who are into horses because they believe that it gives them an elite status. Others believe (usually erroneously) that the horse business will be financially profitable. In *Natural Horsemanship Explained* I dealt extensively with the role players, those who enjoy posing as a Western cattle baron, as a Cherokee warrior, a prince or princess or a

medieval knight. Now just because they role play does not mean that they are not genuine horse lovers, not at all, but neither does it guarantee that they are.

Just as we doctors of veterinary medicine see people select dogs to express their needs, so do some horse persons. Familiar to my profession are those men unsure of their masculinity who choose a dog with a reputation for ferocity such as a pit bull, Doberman or Rottweiler. Often these dogs are quite friendly or even timid and it is interesting to see how disturbing that is to the owner. Others are as hostile as the owner hoped they would be. This satisfies the owner, but not the veterinarian who has to handle the patient.

Similarly, some people revel in their horse's uncooperative an often dangerous behavior. The animals we humans select often mirror our own insecurities and emotional problems. In other cases the misbehavior of the animal causes consternation to the owner. They don't <u>want</u> a dog or a horse inclined to injure people.

But this book does not address those common problems. It deals with a quality I have puzzled over in myself and now that I understand it, finally, it enables me to understand it in other people and gives me the opportunity to express my interpretation. What is it that causes so many of us to devote our lives to horses? What is it that makes us horse lovers?

I have devoted Chapter Three of this book to those people who made a dramatic mid-life career change, in order to work full time with horses. They often gave up a profitable and successful career in an unrelated field.

Another chapter is about those who became horse lovers as children, and subsequently devoted their lives to horses. I am one of those people.

In either case, horse lovers, almost without exception, have two personality characteristics:

1. They are animal lovers. Even though the horse is the special center

of their attention, they have an affinity for all animals. In other words, not all animal lovers love horses, but all horse lovers love animals.

2. They have artistic ability. To the best of my knowledge, this link, which I think is genetic in origin, has never been formally described before. Again, not all artists are horse lovers, but nearly all horse lovers are artists.

That's what this book is about.

Chapter

1

The Nurturing Instinct

I believe that there are two factors involved in the personality this book is about–the dedicated horse lover. The first of these will be discussed in this chapter. It is The Nurturing Instinct. In the next chapter we'll discuss the second quality, Artistry.

The nurturing instinct is present in MOST (but not all) women and SOME men.

Most women have a strong nurturing instinct but to varying degrees. It is a powerful factor in how effective a mother a woman is going to be. The nurturing instinct is the principal reason certain people choose to become foster parents. It encourages adoption, often of multiple children. It is a major motivator in career choice, leading many women to become teachers, especially pre-school, kindergarten, and primary grade teachers. Others are attracted to nursing or other careers in human medicine.

In many women the nurturing instinct directs them into careers with

animals, such as veterinary medicine, veterinary technology (nursing), pet training, pet grooming, and so on.

In October of 2008 I was a speaker at the annual convention of the Association of Pet Dog Trainers (ADPT). Hundreds of trainers jammed the lecture hall. They were mostly women. When the convention was officially opened, the local humane society led in a parade of dogs needing homes. A great swell of sound filled the hall. "Aaaaaah!" It was the sound of sympathy, of love, of adoration, of compassion; the voice of the nurturing instinct.

I live in Ventura County, a Southern California county between Los Angeles and Santa Barbara. We have a two year college here called Moorpark College. It is a very ordinary school except in one respect. It has an Exotic Animal Training and Management program (EATM), the only such program in the world. The facilities include a zoo, the only college with a zoo in our country. Graduates receive an Associates of Arts degree, and all of them find jobs in the animal world.

Our veterinary practice served the EATM program from its very inception, when it was a much criticized pioneering program and the zoo was an improvised ramshackle affair.

Ultimately one of my practice partners, Dr. James Peddie, became EATM's resident veterinarian, a faculty member, and program director.

Women eagerly applied for admission to Moorpark College's EATM program, leaping at the opportunity to learn about and to work with elephants, wolves, tigers, ostriches, and all other zoo species.

Today the EATM student body is over ninety percent female. The major reason for this is the nurturing instinct.

Before I went to veterinary school I obtained a bachelor's degree in animal husbandry at the University of Arizona College of Agriculture. There was one young woman in the class, and she was the butt of a lot of teasing and derision by some of her male classmates and even by some of

the faculty. Back in the nineteen forties it was widely considered unseemly for a woman to study livestock management.

Today in most schools of animal husbandry there are as many or more female students than male. In my youth, you didn't see many girls showing livestock at agricultural fairs. At all of the fairs I have attended in the past two or three decades, more girls were showing livestock than boys in the 4-H competitions.

Historically, men have completely dominated the horse industry, in past times.

After World War II the horse population of the United States of America shrunk to a little over two million. Then, in a half century of unprecedented prosperity as the standard of living grew to unexpected heights, the horse population exploded. These were mostly recreational horses–companion animals–and they were primarily owned by women. The industry today is strongly in female hands.

These things are happening because, once the doors of equal opportunity opened to women, the powerful nurturing instinct which leads women to a love of animals and a desire to work with them found an outlet.

Why do some men have a similar strong nurturing quality? I'm not sure, but natural selection probably had a lot to do with it during the hundreds of thousands of years that we were a stone age people. Too, artificial selection may have played a role, with females preferring and seeking a solicitous and caring mate.

I did zoo practice throughout my career and whenever I considered the best diet or environment or management for an animal, I thought about its natural habitat in the wild. So, for example, it was prevalent to feed the big cats meat. Horses or live stock were butchered and the meat fed to the lions, tigers, leopards and so on. It was very common to see bone deformity in such cats. I thought about how these cats lived in the wild. They didn't just eat meat. They ate other animals, and they consumed all

of their prey. This included the blood and the bone which are rich in calcium. Butchered meat has very little calcium in it. It is high in phosphorous but not in calcium. This led to a disease called Nutritional Secondary Hyperparathyroidism. No wonder so many zoo cats had deformed legs and spines. I supplemented the cats' diet with bone and the problem was solved. Today most zoo carnivores are fed balanced commercial diets, just as most of our dogs and cats are fed.

In order to understand human behavior we have to do the same thing: consider what nature intended for our species.

Turn back the clock fifteen thousand years. All of the humans on the planet were stone age people. They looked just like us because fifteen thousand years is a brief period of time when one considers the process of evolution. But they were primitive. "Savages" if you will.

The men hunted. Fish and game were the primary protein sources in all primitive peoples. The women gathered. They gathered fruits and roots, berries and seeds, vegetables, insects and whatever else was edible.

When the men were off hunting or at war with neighboring tribes, the women cared for their children. Guided by the advice of elders and by the powerful nurturing instinct, most women were very effective mothers. Because they nursed their offspring for several years (which inhibits fertility), the birthrate was low. Moreover infant mortality was undoubtedly high. So mothers had extensive contact with their children.

The nurturing instinct isn't learned behavior. It is instinctive. We are born with it and most women have it , and some men do as well.

Animals that live in groups, like dogs, wolves, horses, antelope, buffalo, gorillas, and Homo sapiens (that's us), readily bond with other species. It's called "surrogate bonding." That means "substitute" bonding.

That's the reason we love our pets as we do. And, it's the reason our pets love us. It's the reason that a horse kept alone is prone to develop bad habits we call "vices." It is why the company of a goat, a donkey, or even a chicken can keep such a horse happy.

To no other professional is the power of the nurturing instinct and the surrogate bond more obvious than it is to a practicing veterinarian. Our animals are often more than a simple possession. They serve as a surrogate offspring, a friend, a servant, and sometimes even as a master.

We have all seen examples of a dog nursing tiger cubs, of gorillas adopting a kitten, of a hippopotamus bonded to a tortoise, of pigs suckling a wolf, of a cat cuddling a parakeet and a fawn nursing a cow.

Goats readily foster-parent foals. Certain breeds of dogs can be put with sheep at six weeks of age, and imprinted by the sheep, they can spend their lives with them and protect them against predators. This is still a custom in the Alps of Europe. The Italian Maremma, the Kuvasz, and the Great Pyrenees are examples of such dogs.

The devotion we veterinarians see some people dedicate to their animals is overwhelming. Moreover, this behavior, motivated by the nurturing instinct is not limited to dogs and cats. We see it in the relationship between owners and their birds, reptiles, or other exotic pets. Nor is it limited to horse owners, even though they are the subject of this book.

I have seen farmers and ranchers who, when a cow is examined and declared infertile, wince and say, "well, she's been a good old cow. Let's just run her another year."

Before I went to vet school, I once worked for a crusty old rancher. He was a whip cracking, tough relic of a frontier culture. Yet, I saw him several times after a long hard day's work, take refuge in his bull pasture where he murmured affectionately to his range bulls, stroking their heads and feeding them treats.

Sometimes the nurturing instinct becomes so strong that it overwhelms common sense, and so we see people who collect excessive numbers of cats, or dogs, or horses and are often unable to properly feed or care for them.

The nurturing instinct elicits compassion. It enables us to be patient

with our children when their behavior is very trying. It makes us more sympathetic, more caring. If we have a strong nurturing instinct we are gentler with our charges.

When I went to veterinary school it was a nearly all male profession and most of the students came from an agricultural background. That is no longer true. Well over eighty percent of all veterinary students today are female and most are of urban or suburban backgrounds, but they love animals.

In my early years of practice I constantly heard women clients wistfully say, "I wish I could do what you do. But, they're not interested in taking girls into vet school."

All that has changed. The opportunities are equal now, and far more women seek admission into the profession than do men. Why?

I believe that the primary motive is the nurturing instinct, the powerful desire to help and care for animals. I lecture at several veterinary schools each year, and regardless of the gender or background of the students I speak to, what I see above all else is the love of animals and the desire to care for them.

Not everybody can become a horse person. Many of us live where there are no horses, or have no possible contact with them and completely lack the expertise needed to handle them safely. Consequently many persons who would, if they could, be horse lovers find other ways of satisfying their nurturing instinct.

Obviously, many people accept the primary target of the nurturing instinct–children!

They put all they have into caring for children whether it be their own, or the children of others. Without such people where would we find foster parents, or kindergarten teachers, or nannies, or pediatricians?

It is notable how many <u>horse lovers</u> combine their affection for horses <u>with</u> their love of children. Scores of my clients were from horse oriented families. Other such people find deep satisfaction in participating

in therapeutic riding programs wherein physically and mentally disabled children are allowed to ride safe and gentle horses with impressive results.

I believe that the nurturing instinct, if it is strong, and whether it is in a man or a woman, is triggered by horses because of their vulnerability.

Unfeeling people may see the horse as a stupid grazing animal that is dangerous to be around and that needs to be shown "who is boss."

But, the compassionate individual sees a sensitive and timid creature in the horse. Flighty and fearful, and extremely perceptive, horses need to be handled with gentle firmness and competent body language in order to achieve the incredible relationship that is possible.

No better example exists than the mustang adopting and training competitions which began in 2007 and were viewed on television by millions of people. In these competitions, called "The Mustang Make-Over", captured wild mustangs were assigned to trainers for a specific period of time. For example, "one hundred mustangs, one hundred horsemen, and one hundred days." Then, at the end of the stipulated period of time, the horsemen had to demonstrate what had been accomplished. The results were sensational. Fully "broke" horses performed beautifully for the judges.

Not every horse trainer has what it takes to accomplish a feat like this. It requires experience, patience, skill, courage and, above all, compassion; a nurturing instinct.

Chapter

2

Art and Horsemanship
The Genetic Link

I believe that there is a genetic link between artistic ability and a passion for horses. Historically, people had to work with horses as a necessity and not necessarily because they loved to do so. Thinking back to my youth I recall how often I saw calloused indifference to the suffering of horses and how often frustration and ineptness were expressed by whipping horses. Today a majority of people who handle horses regularly do so because they choose to do so. With rare exceptions people who choose to work with horses as a livelihood do so because they have an affinity for that animal. Most of the time their love for horses keeps them in an occupation requiring constant contact with that animal even though they could make a better living doing something else. I include breeders, trainers, farriers, grooms, and equine vets in that statement. Considering the hours, the physical hardships, the risks, and the uncertainty in these occupations, you realize that most of these people could be making more

income elsewhere, yet, their love for the horse keeps them doing their chosen work.

I became aware long ago that this kind of horseman, the kind that choose their life's work because they love horses the way other people are attracted to cars, or boats, or aircraft, often have artistic ability.

This is nothing new. Leonardo de Vinci, one of history's most versatile and talented men had the combination. The horse was one of his most favored subjects.

A disproportionate number of great American artists were lovers of horses. Charles Russell and Frederick Remington were just two of America's most honored artists of the nineteenth century. Cowboy artists like Will James and Edward Borein are abundant. Today such organizations as the Cowboy Artists of America are disproportionately numerous in the art scene.

Not everybody considers cartooning an art form, but I treasure my life membership in Cowboy Cartoonists International, and the members' talents are certainly a form of illustrative art.

An amazing amount of sculpting done today depicts the animal that the invention of the combustion engine nearly made extinct.

Artistic talent is not just expressed in paintings, drawings, and sculpture. Poetry is an art form and is there another occupation, considering how few working cowboys exist in a nation of 300 million people, that is so prolific as are the cowboy poets?

How about music? Look at the amount of music in our culture that is contributed by a relatively rare occupation, the working cowboy.

Of course, cowboys and the ranching industry only represents a piece of the modern horse scene, but those who choose this work as a career <u>must</u> love to work with horses. If they don't, they are certainly not going to stick with that job.

Once, perhaps, cowboys chose that career because they could not

find work elsewhere or simply didn't know how to do much else. But, that's certainly not true in modern America. Those who choose a career involving horses <u>must</u> be attracted to that animal and a disproportionate number of those people have artistic ability. Even if they are unknown professionally, so many of them create art as a hobby or pastime. There <u>must</u> be a genetic link.

If you'll think about it, many of the qualities that it takes to make a great horseman are similar to those required to make an artist. Both must be observant, sensitive, and have feeling for their subject. Both require manual dexterity, and gentle hands. Both require patience and imagination.

It is no coincidence that horsemanship has been described as both an art and a science.

Artists traditionally have lived in poverty in order to pursue their passion. What other job requiring skill, courage, persistence, and enduring physical hardships for an absolutely meager salary can compare with cowboying?

Artists, cowboys, most jockeys and farriers, and most horse trainers are motivated by their passion. They'd <u>like</u> to make more money, but their love for what they do keeps them in their career.

Writing, too, is an art form and just a moment's consideration will make one aware of the enormous amount of creative writing that was and still is devoted to the horse. Horse books include many classics written throughout history and they continue to be published in numbers disproportionate to the role of the horse in modern society. Horse magazines have an amazing circulation, and, now, horse oriented television is immensely popular when one realizes that less than one percent of the population of the U.S.A. are horse owners.

Now that the human genome has been worked out , I think it is only a matter of time before someone announces the gene that carries on it an affinity for horses and an inborn artistic ability.

I am sure that there are millions of artistic individuals who have

never had the opportunity to have contact with horses, but whom, if given the opportunity would become horse lovers.

Take Baxter Black for example. Best known for his humor, he is also a very sensitive poet, a musician, a composer, and an author. A doctor of veterinary medicine, he was attracted to that profession by his love for livestock and horses. I'll bet he can draw, too.

The link between artistry and horsemanship is apparent when one looks at the decorations horsemen throughout history have applied to their saddles, bridles and harness, their spurs, saddle pads, to their own costumes and to the horse itself.

Horsemanship – <u>Real</u> horsemanship – and art are inseparable. Masters of both are gifted people and I believe the link is in their genes.

Most of what follows in this book will be a biographical description of horse lovers. In selecting them I had only one rule–I had to know them personally.

Obviously, there are countless people who belong in this book: People who have devoted their lives to the horse, either from childhood, or people who, in mid-life, made a dramatic career change in order to work with horses. Note that those in the latter group often forfeit a successful and profitable career to satisfy their most elemental passion; to work with horses. So, in the first section of this book that's what we'll regard: Those horse lovers who made a dramatic mid-life career change. But, isn't it fascinating that both groups of people who decide to devote their lives to the horse are, almost without exception, artists? Note, too, that many of these people do not regard themselves as "artists." Some, despite their obvious talent, denied to me any artistic ability until, after being questioned persistently, they conceded. Perhaps, the word "art" initially implied drawing and painting to some of these horsemen. Their creativity in other forms of art they tended to dismiss as an "interest" or "hobby."

But, art is a uniquely human quality. Many of the things that in the past were said to differentiate Homo sapiens from all other creatures are

now known to be fallacious. We are <u>not</u> the only tool using species. We are <u>not</u> the only species to use logical deduction to solve problems. We are <u>not</u> the only species in which certain behaviors which are not instinctive, but <u>culturally</u> acquired, become common. But, we <u>are</u> the only species which engages in creative art. Yes, birds sing and various species decorate their abodes, but these behaviors are in their DNA and are not independently expressed. Only mankind draws on cave walls, and sculpts, and carves, and composes poetry and music. I spent my entire life working with an immense variety of animals. I believe that only human beings can experience the aesthetic exultation that artwork can evoke. And, one of the purposes of this book is to let it be known that this quality – artistry – is somehow linked to the love for the horse.

Chapter

3

People Who Made Mid-Life Career Changes in Order To Work With Horses

Jim Parchman

Before I retired from the practice of veterinary medicine in 1987, my clients included Jim and Gail Parchman. They had a nice home and three horses. I didn't know what Jim did for a living, and I'm not a nosey person, so I never asked.

Jim started to shoe his own horses and one day asked me to evaluate his work. I told him, truthfully, that he was doing as good a job as most farriers, and frankly, a better job than some.

I have always respected the skill and difficulty of shoeing horses, primarily because I had to do some of it as a ranch hand when I was young. I became aware, early in my veterinary career, that one part of being a good horseshoer is artistic ability. Forging a shoe and fitting it to a horse's

foot is sculpting in iron. The best horseshoers in my practice had an artistic bent, and often did decorative ironwork as a hobby.

In the early days of my practice, when the Conejo Valley was an agrarian paradise rather than the suburbia it is today, the various farriers were not formally educated. One was a veteran of the U.S. cavalry, and he did a good job. Another, a self taught cowboy, was less competent. The best one had served an apprenticeship, and was also a talented sculptor with iron, creating decorative pieces.

Today nearly all of the farriers I know in my area are educated individuals. Some are graduates of good horseshoeing schools. But most, ironically, were involved in radically different careers before they decided to give it all up and become full time horseshoers. For example, two were high school teachers. In mid-life they gave up that career to shoe horses.

The person that I interviewed first for this book, and the one that made me decide to devote this part of it to those who made radical mid-life career changes was Jim Parchman.

Jim was 43 years of age when I learned that he had decided to become a full time farrier. I had been retired two years and at sixty-two I was getting tired of trimming my own horses' feet. So, I had Jim become my regular farrier, trimming feet and occasionally shoeing them as needed.

After I decided to start this book I telephoned him and asked him what he had done before he became a full time professional farrier. His answer stunned me.

"I was an astrophysicist."

I was speechless for a moment.

"An astrophysicist?"

"Yes, I have a degree in astrophysics and I worked for twenty-five years as an astrophysicist for the U.S. Navy at Point Mugu."

There is a navy base at Point Mugu in our county, within

commuting distance from the Conejo Valley where we live.

"Did the navy retire you?" I asked.

"Oh, heck no! I could still be working for them. You know, I'd been shoeing my own horses for a few years and then some neighbors asked me to shoe their horses, and then one day I decided that I'd rather be doing this and I just quit and became a full time horseshoer. I'm perfectly happy."

"What is it you love?" I asked. "Is it working in 105° temperature on a hot summer day, or the flies buzzing around you, or getting kicked once in a while?"

He laughed, and answered me profoundly:

"Look," he said, "no matter what you do it has an upside and a downside. It's like that with horseshoeing. But, I just decided I liked working with horses and being my own boss more than what I was doing. So, I changed!"

"Okay," I said, "now, I have another question. Do you have any artistic talent? I have noticed that most horse lovers are artists."

"Oh, no," he laughed. "Now, my wife is a horse nut and a talented painter."

"I know that," I said. "But, what about you? You don't draw or paint?"

"Oh, no, no! You have the wrong guy!"

"Sculpt, woodcarving?"

"No, no, no way! No talent!"

"Music?"

"Nope! Nope! Not me!"

"Well," I said somewhat disappointed. "I guess you're the exception that proves the rule."

We went on discussing various things, then he said, "well, you know, I've been a cartoonist all my life."

I said, " so have I, and I've had many people tell me that it is an art form."

"Really?" He answered.

I told him I had eight books of veterinary and ranching cartoons published and some serious and accomplished artists told me that cartooning is a specialized artistic talent.

"Really?" He said. "I never thought of it that way."

Then, he explained that he cartooned in high school (as I did) and cartooned a love letter to the girl who eventually became his wife.

I learned one thing with this first interview: when a horse lover is asked if he or she has artistic talent, do not be too quick to accept "no" for an answer, especially if that person is male. Persist in the interrogation and eventually an admission of artistry may come out.

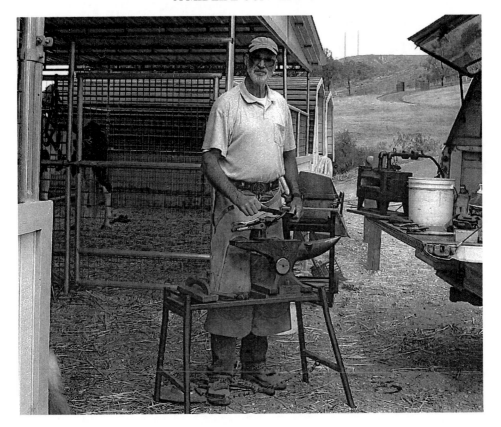

Jim Parchman at work

Allen Pogue

In Dripping Springs, Texas, not far from the city of Austin, Allen Pogue, a trick horse trainer lives on his Red Horse Ranch. He is a graduate engineer and, over a twenty year period, progressively became more and more involved with horses.

Finally, at 50 years of age he became a full time trainer at the dawn of this new century. Allen was influenced by a number of distinguished horsemen, such as the classic horseman J.P. Giacomini.

He is kept busy these days, full time, doing performances and demonstrations at equine expositions and fairs, holding horse training clinics, and making videos teaching his techniques.

Our acquaintance began with his interest in my foal training

program. Using imprint training of the newborn foal as a foundation, he added aspects to the subsequent sessions that have never occurred to me. In my book on this subject, Imprint Training of the Newborn Foal (Western Horseman, 1991) I made the following statement that, in the future, "More competent trainers than I will adopt this method and use it to achieve things that I am not capable of achieving." I can think of no trainer who has more vividly confirmed my statement than Allen Pogue. By three to four weeks of age he has his foals so bonded to him, so complacent, so obedient and such willing performers that even I would not have thought it possible. All of this is dramatically shown in his video series. Importantly, it is obvious that there is no loss of relationship between mare and foal, and these foals are in no way "spoiled." They are respectful, and when you see his subjects after they are grown, the permanence of the training is completely apparent.

Interestingly, as has occurred with several of the horse lovers I interviewed for this book, when I asked about artistic talent, the answer was an immediate, "No!"

"You don't draw or paint?"

"No. I wish I could."

"Sculpt?"

"No!"

"Leather work or wood carving?"

"Wood carving? Well, not exactly," he said.

"But, I have been making furniture for many, many years."

"Really?" I said surprised. "What kind of furniture?"

"Oh," he said, "mostly Western type furniture that I designed. My furniture has been in art shows all over Texas."

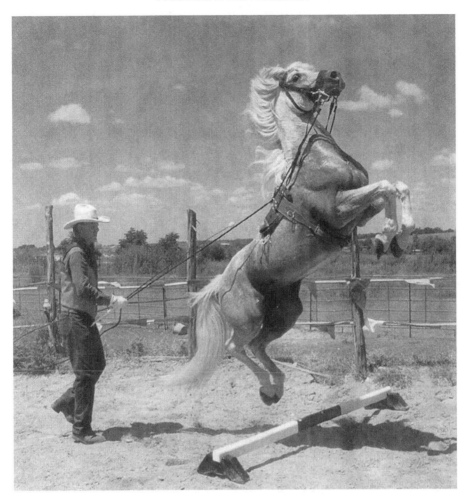

Allen Pogue and Hasan performing a courbelle

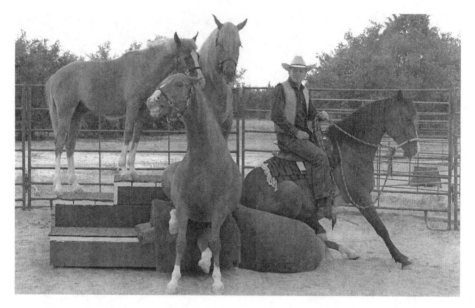

Allen and his trick horses

Steve Edwards

When I interviewed mule trainer and clinician Steve Edwards of Queen Valley, Arizona for this book, I concluded by asking him the key question:

"Do you have any artistic talent?"

"Oh, heck no," he replied.

But, having learned not to accept this answer from horse (or mule) lovers at face value, I persisted.

"No artistic ability?"

"Nope!"

"You haven't ever painted?"

"Well, not exactly."

"What do you mean?"

"Well, you know I had an automobile body shop and I was pretty successful. One reason was that I could paint murals on the side of cars."

"Steve," I said, "that's artistic ability."

"Okay, if you say so."

Then, I asked, "what about music?"

"Not really."

"Poetry?"

"Oh, sure! I do cowboy poetry!"

"Steve," I insisted, "writing poetry involves creative artistic talent!"

"Yeah?"

"Sure! If you were in a room with a hundred people, how many of them could sit down and write a poem?"

He thought for a while and then answered, "not many, I guess."

"Writing poetry is an art form," I told him. Not many people can do it. In fact, any form of creative writing is an art form. Many, many highly intelligent and learned people find it difficult to write. I think a majority of such people lack real writing talent."

"I guess you're right," Steve mused. Then, he added, "you know I write, too. I've done quite a bit of writing."

There you are!

I think I met Steve at Bishop Mule Days, the world's largest mule show held every May in the California outback town of Bishop at the foot of the snow capped Sierra Nevada mountains. Our friendship began when Steve invited me to do a seminar on equine behavior.

A long-time cowboy, Steve had a special penchant for mules and what was a part time job and hobby became a full time occupation once the Revolution in Horsemanship blossomed.

Today, Steve is one of a very few trainers and clinicians who

specialize in mules. They fill a needed niche because, contrary to anybody's expectations the mule has made a remarkable comeback in American culture. Mules are increasing in popularity faster, proportionately, than any breed of horse in America.

I packed for the U.S. Forest Service in the mountains of Colorado the summer of 1950. We badly needed mules in the extremely rugged terrain close to timberline, but none were to be had. The thousands of mules used by the U.S. army in World War II were not available. Some

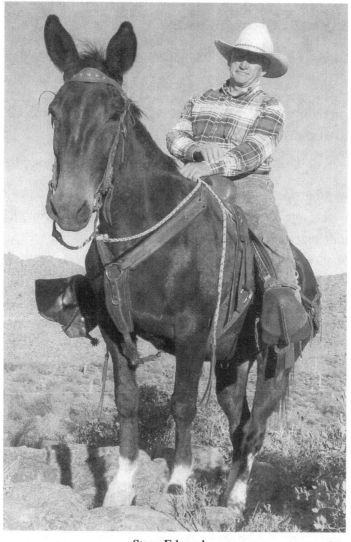

Steve Edwards

were serving at the Grand Canyon transporting tourists and supplies. Many had been given to Mexican farmers during the AFTOSA (Foot and Mouth Disease) epidemic when thousands of oxen had been killed in an attempt to halt the spread of the disease. Sadly, many mules in the Pacific theatre of war had simply been killed rather than bring them home.

Only fifty years earlier seven million mules were in use in the United States, on farms, hauling cotton, packing supplies into harsh terrain, in our mines, pulling stage coaches and homesteaders' wagons. Now, in 1950, no mules were to be had. The Forest Service accepted low bid on a pack string and there near Eagle, Colorado, we had to use a broken down bunch of rodeo bucking horses as high altitude pack animals. We needed mules. There were none.

So, the mule is back, principally as a riding animal, and there are now many mule shows in the country, with mules competing in English, Western, and Driving classes, and even in dressage. Mules can be seen on many trail rides.

Many people ask me why I have mules as well as horses. I explain, "I love horses. I respect mules."

So, Steve Edwards is busy now, along with a few other trainers, specializing in mules. They are all horsemen. They love horses. But, they prefer mules.

Although, Steve was slow to admit his artistic talents, he finally admitted that he liked to draw as a kid. But, he wasn't in the least reluctant to talk about his love for the equine. Even when he was in the car repair business he rode a horse to work, and worked on ranches when he could. Prior to that he had cowboyed full time, packing mules, and riding for the Yolo Ranch near Prescott, Arizona.

Then, fifteen years ago he gave it all up to become a full time mule trainer and clinician.

Fred Stone

Fred Stone is the best known living horse artist in the world. His murals adorn race tracks in countries on several continents. His work can be found in museums, art galleries, the White House, and in the homes of horse lovers everywhere.

Fred decided to become a painter of horses at the age of forty-six. He had been trained as a young man from Los Angeles, and had done commercial art.

But, he ended up in sales after developing a toilet system for the boating industry that would prevent pollution of the water. His efforts helped establish present boating regulations about waste disposal.

It was his daughter who led him into horse art. She had worked as a groom and stable hand at the racetrack and was now a track agent.

Fred's career change was abrupt. Inspired by the horses his daughter exposed him to, he began to paint them and the rest is history.

Fred and his wife Norma lived in a modest home in Agoura, a few miles from my veterinary hospital in Thousand Oaks. They still live in that same house. They were regular clients. He had casually told me one day that he was in the chemical toilet business for recreation vehicles and boats.

Many years later, after I was retired, I was in a local saddlery, admiring a painting of jockey Willy Shoemaker. The proprietor came over to me and said, "he's good, isn't he?"

"Who?" I said. "Fred Stone? I consider him to be the best horse painter of all time. I have always wondered if he could capture people the way he captures the personality of a horse. Now, I see that he can!"

"Yes," the saddle shop owner said. "Oh, by the way he was in here the other day and asked if I knew anybody who had mules. He wanted to do a mule painting, so I told him that you had some mules."

I was amazed. "Fred Stone was in here?"

"Sure! He come's in all the time. Don't you know him? He knows you!"

"The only Fred Stone I know lives in a little house in Agoura with two horses in his yard," I responded.

"That's him! That's Fred Stone!"

"That's Fred Stone?" I was astounded. "I thought he lived in Kentucky! He's always painting Thoroughbreds. The Fred Stone I know is in the toilet business!"

"No! He changed careers! He's been a full time horse artist for years now!"

I telephoned Fred that night. He said, casually, "oh, didn't you know that I switched to art full time quite a few years ago? Why don't you come over and bring Debby. I'll show you my studio in my yard."

We did this a few days later and I told Fred, "you, know, you're paintings are so lifelike that I can read the horse's personality just by looking at the picture."

"Really?" Said Fred. Then, he reached for a portrait of a horse's head near his desk and said, "okay, tell me about this one."

"Thoroughbred mare," I said. "Middle aged. About twelve. Well bred. She's a sweetheart. Kind and gentle. Loves people. Always good to work around."

"Remarkable!" Said Fred.. "You can do that just by looking at her head?"

"Sure," I said, "anybody that works with thousands of horses can do that. What's remarkable is that you can capture that in oil."

"Watercolor!" He said.

"What?"

"Watercolor!"

Fred's remarkable talent is able to capture the very essence of a

horse's personality in watercolor.

"Okay," he said, "let's see you do this one!"

"Different kind of horse," I replied. "Older horse, Thoroughbred. A stallion. This is a horse I'd tread softly around. I would be careful not to agitate him because if we got into a fight, he's liable to win it!"

Fred smiled. "I never met this horse. But, I studied many of his photographs before I began this painting. This is Man O' War, and from what I've heard, he was just like you said."

You see, sometimes a horse lover learns that he is an artist, and sometimes an artist learns he is a horse lover.

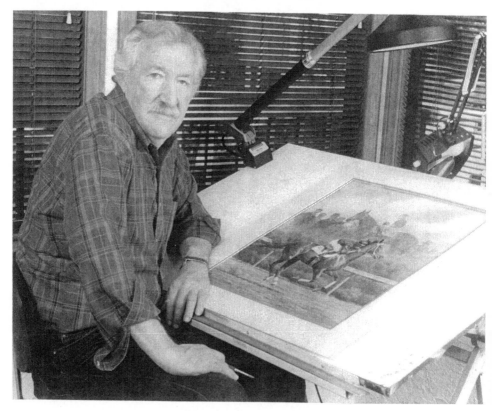

Fred Stone in his studio

G.R. (Butch) Martin

Why would an executive in the corporate world, who had a good salary and a corporate airplane, quit in his mid thirties and give it all up to become a Morgan horse breeder, a mule fancier, and a cowboy poet and musician? Butch Martin, a resident of Grants Pass, Oregon did it. His love for horses and mules motivated the career change, combined with his penchant for the creative arts. Butch, whose singing voice is very similar to Burl Ives, writes music, composes poems, tells stories, plays the harmonica, has authored books and sings ballads and folk music. He has quite a following in the United States, but his real fan club is in the United Kingdom, Denmark, Norway, Belgium, France, Germany, Austria, Switzerland, Italy, Australia and New Zealand.

Why did he make such a profound mid-life change?

"I liked what I was doing," he says, "but, my roots called."

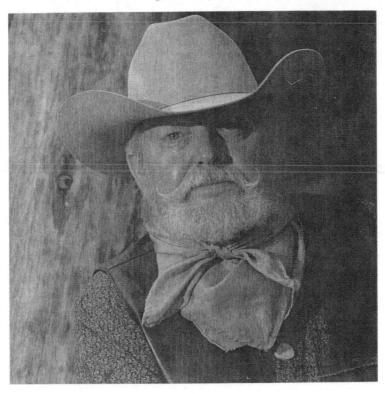

Know How To Ask Me First
By Butch Martin

Through the ages I've done your bidding
As a war horse or working in teams
Carried everything from conqueror to mail
To fulfill your many dreams

I've been referred to in many ways
From outlaw to best of friends
You brought out these things from inside me
You've made me whatever I am

It was never meant that I should be ridden
That's not an idea I had
But you showed me, it could be done

And it didn't work out half bad

There was some who have tried to subdue me
That's when I turn out the worst
But to others I've given my heart any my life
You've gotta know how to ask me first!!

Joe Camp

Joe Camp is best known as the motion picture producer who created the Benji series, the movies about the adorable little dog with super human intelligence. However, he made other movies such as Hawmps which is based on the historical fact that the U.S. army imported camels into the arid American Southwest for military use in the nineteenth century. It is significant that so many of Joe's movies had an animal theme because this man is an animal lover who qualifies to be in this book, although, he did not fully recognize the depth of his love for horses until rather late in life.

Joe was in his sixties when a chance meeting with Monty Roberts inspired him to learn all about Monty's "Join-Up" horsemanship. For two years he immersed himself in the Revolution in Horsemanship, reading, watching videos, attending clinics, and applying the concepts with great success to his own horses. Then, he wrote a book, The Soul of a Horse: Life Lessons from the Herd, sent a copy to me, and then asked me for my critical opinion of it.

What I learned is that you are never too old to learn, because The Soul of a Horse: Life Lessons from the Herd is a remarkably good book. Considering how recently Joe Camp got involved in high tech horsemanship, he sure caught on quickly.

Prior to his 2005 conversion to Natural Horsemanship, Joe's experience was rather limited. When he was in junior high school he got the idea of taking lessons in English horsemanship for a year. Then, he quit. But, he says something always remained. He was always inclined to

stop and watch horses, and liked to hang out with them.

In 1974 he bought four horses, but his career kept him too busy to do much with them. It wasn't until he did a trail ride in 2005 that his conversion to Natural Horsemanship began.

Asked about his artistic leanings, Joe can go on a long time. He plays the hammer dulcimer, an ancient musical instrument, and he has played the Celtic harp. He has written music. He has been a movie writer and director. He likes art. He is a Monet fan. He paints and has written books in which he did most of the photography.

If the theme of this book is that a true horse lover is motivated by an innate love of animals stemming from a strong nurturing instinct, combined with a genetically based talent for creative artistry, surely Joe Camp serves as an outstanding example of such a person, especially one who did not fully recognize his role as a horse lover until rather late in life.

Joe Camp, Benji, and one of his beloved horses

Nancy Jones

In 1996 Nancy Jones phased out of her show business career. Turned off by the increasing materialism in that industry, and somewhat disillusioned, she thought about opening a dude ranch on the Big Island of Hawaii. That's the island of Hawaii, larger than all of the other islands combined, the one with the active volcano, and with several large cattle ranches, including the immense and famous Parker Ranch. She bought a ranch not far from Waimea where the Parker Ranch headquarters is located. Then, finding horses that needed homes, she ended up stocking the ranch with unwanted horses. She calls her place the Circle J Horse Sanctuary.

Nancy Jones is a horse lover, and she was instrumental in the success of Hawaii's first horse expo in 2008, at which I was privileged to participate. Her show business skills were put to good use in organizing and promoting that horse expo.

When she left the entertainment industry she admits that she gave up big bucks. She had been a very successful writer, producer, and director.

Starting as a show business secretary in Los Angeles, she ended up with her shows being nominated for twenty Emmy Awards.

Nancy Jones at her Circle J Sanctuary in Hawaii

She was the first female producer of game shows such as Jeopardy and Wheel of Fortune. She produced for Merv Griffin and for Universal Studios. So, it is interesting, and significant that with such success, and still being an active, youthful person, that she gave it all up to run a horse sanctuary for "the retirement and rehabilitation of horses."

Nancy was raised in Oklahoma and had horse experience as a child.

But, between her childhood and her retirement from "show biz" she had no contact with horses except for an occasional dude ranch vacation.

Her artistic talents were manifest early in life. She minored in art in college and majored in theater arts. She has done ceramics. Her success in the entertainment industry has largely been due to her artistic creativity. But, getting to know Nancy Jones has revealed to me the other aspect of her character that qualified her as a horse lover. She has a powerful nurturing instinct.

This, I believe, is why she is a kind, thoughtful, and considerate person.

Dennis Gaines

I think that Dennis Gaines belongs in this chapter on people who made mid-life changes into the horse industry because he was thirty-one years of age when he made the abrupt decision to become a working cowboy. Prior to that he had done various things, including working in the oil fields. He says he was too restless and adventurous for most ordinary jobs.

So, having made a decision to become a cowboy, he printed up some flyers stating that he was available. He had little riding experience, but drove around West Texas and New Mexico seeking work. At the famed Matador Ranch he was asked two questions: "Got any trouble getting up early?" and, "do you do drugs?"

He cowboyed for the Matador for the next eight years. Afterwards he worked for other ranches and still does sporadic day work and gets invited to brandings and roundups.

He learned the cowboy skills on the Matador by "studying hard until I became competent." He adds that the most enjoyable work he has ever done is ranch work.

His poetry is pure art. He's done one book, *New Tradition – Western Verse*. Dennis recited at the Elko Cowboy Poetry Gathering in 1991, and then, although he had no ambition to become a professional poet, he did so in 1996. Today he is a full time Western poet and story teller.

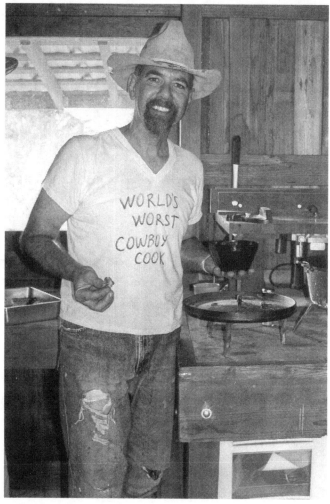

Dennis as a cowboy cook

His artistry is not limited to poetry and story telling. He is a good carpenter and built a barn he calls "a work of art." He is a creative cook and enjoys cooking.

Dennis Gaines, former big ranch Texas cowboy is now a member of

the Texas Commission of the Arts.

A cancer survivor himself at fifty-five years of age, he is now dedicated to helping cancer victims and is working on a program called "Cowboy Tour for the Cure." It's goal is entertainment and cancer education for general audiences.

"I want to make a difference for some people," says Dennis Gaines.

The Centaur's Better Half

I have thrilled with desperate fear to your panic and your rage,
And reveled in your frolic on a frosty winter morn.
I've smelled the stench of terror like a fox trapped in a cage,
When you've plunged from heights through rock and rough with self –
destructive scorn.

You have taken me to secret worlds I would not dare alone,
Where wild kings rule and the timid turn to flee.
Eye-to-eye we've faced the brute and challenged for the throne,
And if we've faltered here and there, the blame must go to me.

We've torn our holes through fortress brush and paid the price in blood,
While the sting of sleet and sand and thorns I've cursed
You've borne me through the sucking bog and swam the cresting flood,
And seen me safely homeward through delirium and thirst.

Your strength and speed you give me when mine will not suffice,
And there's magic in your elegance and grace.
We've stacked the chips and risked them all on one throw of the dice,
And win or lose, it matters not; the glory's in the race.

You have lifted me above the plane of ordinary men;
From your back I have watched Life's grand parade unwind.
We've partaken of a feast beyond the common mortal's kin;
My destiny and yours are interwined.

"Centaur of the Plains," some say; I smile and tip my hat.
It pleases me to strike that mystic chord.

A MIDLIFE CONVERSION

Afoot I'm just a man, it's true, and a poor excuse at that,
But mounted I'm a monarch far above the teeming horde.

What man of heart and soul could see a horse and then deny
The existence of a God who gave us birth?
Atheists and skeptics may declare it all a lie,
But I've found a piece of Heaven here on Earth.

For I've coursed the virgin valleys that most eyes have never seen,
and crested hills to greet the dawn while townsmen lay a-bed.
My land is grand and glorious in a world that's small and mean,
And you, my friend, have saved me from that place of sin and dread.

Where men of false nobility pursue their base desires,
And piety and virtue are a crumbling, cracked facade.
While some may feed on hate and greed 'round paganistic fires,
From your back I've kissed the prairie wind and touched the face of God.

Though wealth and fame elude my grasp, I count myself as blessed,
And I pray I'll keep your confidence and trust.
A worthy thing it is that man should try his best,
And the lesson I have learned from you is that I can, and must.

True dignity and courage are the virtues you possess,
And I envy you those attributes, my friend.
For though we strive to lofty goals, in truth I must confess
That self-respect is all that really matters in the end.

I know a day will come too soon the strength will leave my limbs,
Through age or cruel infirmity or everlasting sleep.
The Centaur then will trod no more the trails grown faint and dim,
And on that day – on that day will I weep.

But 'til that day I'll have no need for salty, futile tears;
We'll reap the wheat and cast away the chaff.
While others seek false prophets through their bitter, wasted years,
I've found my truth and purpose on the Centaur's better half.

Dennis Gaines © November 1993

Dennis Gaines recipe for:

SWEET POTATO CINNAMON ROLLS

Spices and add-in:
1 ½ cups red flame raisins
1/4 cup rum
1/3 cup granulated sugar
3/4 to 1 cup powdered sugar
Adams Cinnamon Sugar
1 stick unsalted butter

Heat rum in small saucepan over medium heat. Add sugar and stir until dissolved. Add 3/4 cup raisins and cook until well blended, about 7-8 minutes. Remove from heat and cool. Can be made days ahead of time and refrigerated. When ready to use, separate raisins and roll in the powdered sugar. Set aside. Reserve left over sugar. Steam remaining 3/4 cup raisins until plump. Cool.

Dough:
2 cups bread flour
2 cups all-purpose flour
1/4 cup nonfat dried milk
1 1/4 teaspoons salt
4 tsps. vital wheat gluten
1 tsp. malted barley flour
1 pkg. Butter Buds
1 cup mashed sweet potatoes
1 cup warm water
1/4 cup vegetable oil
1/4 cup sorghum, honey or molasses

2 ½ teaspoons active dry yeast
1/4 cup warm (110°) water

Sift together dry ingredients, including leftover powdered sugar from rum raisins. Add sweet potatoes and stir with wooden spoon. Add yeast to 1/4 cup warm water and wait five minutes for it to foam (proofing). Add oil,

water and syrup, then yeast. Add rum raisins and ½ cup cinnamon chips. Stir until dough leaves sides of bowl, then turn out onto floured board and knead for 6-8 minutes. Place dough in large, greased bowl, turning to grease all around. Place covered bowl in warm, draft-free area and let rise about one hour, until double. Butter 15" cast iron skillet or 16" Dutch oven with I Tbsp. butter. Turn dough out of bowl onto board that has been sprayed with nonstick cooking spray, roll out with greased rolling pin until about 1/4" thick. Brush half of the melted butter over dough, sprinkle with ½ cup cinnamon chips evenly over dough. Beginning on long side, roll up dough, then slice into I" rounds. Turn rounds on side, then arrange in skillet or Dutch oven. Pour rest of melted butter over top, then more cinnamon-sugar. Let rise in warm draft-free place for one hour.

Pre-heat oven to 350°. When rolls have risen, place pan on middle rack of oven, and bake covered, for twenty minutes. Uncover pan and bake another twenty minutes, being careful not to over brown, then remove to cooling rack. Glaze if desired

Maple Glaze:
½ stick unsalted butter
1/4 cup maple syrup
1/4 cup powdered sugar
Hot water

Melt butter in heavy-bottomed, medium saucepan. Add maple syrup and powdered sugar and continue cooking until all is dissolved and well blended. Ad hot water 1 tablespoon at a time until desired consistency is achieved. Pour over cinnamon rolls while they are still warm.

David Lichman

This book includes every interview I did for it. None were eliminated because the person interviewed did not fit the "mold" that is my theme. No selections were made in order to support my concepts.

I did not originally plan to include David Lichman of Sacramento, California. Dave is best known as a Tennessee Walking Horse trainer and

as a clinician of the Parelli school. I knew him well enough to recognize him as a true horse lover, but I knew little of his personal life. For example, I did not know of any artistic talents.

Dave did a career project in the seventh grade. He had already decided to become a horse breeder. He says that he was drawn "inexplicably" to horses. Perhaps this book will help him to understand himself.

At eighteen he tried to learn to jump. He has been a bass player since the age of thirteen, and played professionally. He says that music is his second strongest passion. There's the connection!

He became a software engineer, but his office cubicle was surrounded by horse pictures.

He won a Tennessee Walker World Championship, got involved in Pat Parelli's Natural Horsemanship program and decided to make a mid-life career change at age forty-two.

But, Dave had married a practicing veterinarian a decade before he made that momentous career change. They owned horses, they say, long before they had their two children, a son and daughter.

Dave, a musician, believes that there is a musical connection to understanding hoof beats. This is certainly an advantage to a gaited horse trainer.

Once, visiting the Navajo Nation to do a clinic, he met an old medicine man. Dave asked him to say a blessing before the clinic began. The old man asked why.

Dave told him, "because inside of me from the beginning, when I was a small child, there was a need to be with horses."

The medicine man, who had started hundreds of horses in his lifetime understood, and said the blessing.

Dave playing his "air guitar"

Dave and Gina Paolillo dance with horses

Ted Blocker

When I talked to Ted Blocker he had been in the horse business for ten years. Ted is an ingenious and inventive maker of horse equipment. For example, he conceived of the Blocker Tie Ring, a clever device which discourages horses from pulling back when tied up.

Prior to his present occupation he was a part time trainer and boarded horses.

Horses are very much a part of the life of this amazingly creative man. So, I was surprised when I asked him if he had any artistic talent, expecting the usual affirmative answer.

"No," he said, "I am mechanically creative, but I have no artistic ability."

"None?" I asked. "You don't draw or paint?"

"Nope!"

"Sculpt?"

"Nope!"

"Music?"

"Nope!"

"Wood carve?"

"No! I'm not artistic."

"Leather carve?"

"Leather carve?" he responded. "I was in the leather business. I designed and sold belts and holsters for police departments, but I sold that business a dozen years ago."

See what I mean? Artistic ability, especially to men, seems to imply the ability to draw or paint. But, creative artistry can take many forms and Ted Blocker is a very creative man.

I once asked Jack Brainard, one of America's most respected and most highly qualified Western horse trainers if he had any artistic ability.

"I collect fine art," he replied. "I have a valuable collection at home." "And," he continued, "I've always been a creative dancer. Of course, now, in my late eighties, I'm not as nimble as I used to be, but I still love to dance." Jack is also a successful author.

Ernie Morris, California's great Vaquero artist, who is also in his eighties, told me that when he was young, he remembered that the best vaqueros, the most talented horsemen, were also great dancers. There again, is the artistic leaning, the timing, the coordination that is necessary in a good horseman.

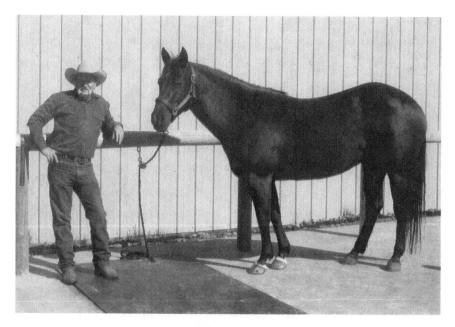

Ted Blocker at home

Rick and Diana Lamb

I am putting this couple together because their stories are so similar. They serve as classical examples of artists who, in mid-life,

discovered a passion for horses and then made an abrupt career change which led to a lifestyle they could have never imagined earlier. Sometimes the artistry precedes the horse involvement, and that's the story of Rick and Diana Lamb.

When I retired from my veterinary practice in late 1987 to become a full time writer and teacher of horsemanship, I telephoned the editor of *Western Horseman* magazine. I had been cartooning and writing regularly for that publication since 1949 and they had published two of my books (*Health Problems of the Horse* and *Imprint Training of the Newborn Foal*) I had an idea for a book to be titled *Revolution In Horsemanship*. *Western Horseman* agreed that the time had come for such a book, but explained that they did profusely illustrated "how to" books, and that I should write *Revolution* and look for a publisher elsewhere.

I shelved my idea and soon was too busy in my second career to think about it.

I met Rick Lamb at a Natural Horsemanship Seminar I did in Arizona two years later.

Entranced with what he was learning, he suggested that I do a book on the subject. I explained that I no longer had time to do such an involved project.

After I got home Rick telephoned and said, "look, let's do that book together. I'll do all the computer work and handle all the illustrations. I'll do the search for a publisher and handle the negotiations. I'll do all the historical research and write half the chapters. All you'll have to do is write the same concepts you teach at your clinics."

"That's the easy part," I said. "You have a deal."

That's the story of how *Revolution In Horsemanship* was created, and it was the beginning of a lasting friendship. Rick and I and our wives have traveled together, participated in clinics, at horse expos, worked on TV shows and videos.

At the "Road to the Horse", that extraordinary annual colt starting

competition, Rick serves as host while I am one of the judges.

Rick Lamb grew up in Wichita, Kansas. By age six he was singing in a church choir. A few years later he learned to play the trombone. By thirteen he was playing the guitar and was soon influenced by the "British Invasion" of popular music.

He became a professional musician by the time he was fifteen years of age and he put himself through college, majoring in mathematics and philosophy, by playing in bands.

After college he moved to Arizona and spent a decade in the computer business, but he continued playing music and, in 1977, he opened his Lambchop recording studio. To this day, now a successful radio and TV host of "The Horse Show," and a frequent equine event master of ceremonies, he still performs as a professional musician when his busy schedule permits it.

Although *Revolution in Horsemanship* was his first literary effort, Rick has since authored other books. In 2004 *Horse Smarts For the Busy Rider* (Lyons Press) was published and in 2008 *Human to Horseman* (Trafalgar Square) became available. Both of these interesting books have sold well so we see that Rick's artistry is not confined to music.

His contact with horses early in his life was limited. He had relatives with a pony, but in 1995 he and Diana moved to horse property near Phoenix. Their interest in horses bloomed and in 1996 he got the idea for a horse oriented radio show. He may have been inspired by the first natural horsemanship clinic he attended, conducted by Pat Parelli in Scottsdale in 1996. He thereafter attended clinics put on by other clinicians and quickly absorbed information about horses from many sources.

Rick and Diana married in 1990. She, too, had a background in the arts. She grew up in urban Southern California and had no contact with horses except for an extensive collection of model and toy horses.

While she was in high school, Diana occasionally rode with friends on rental horses. When she was thirteen she got dumped riding bareback

and ended up with both arms in casts.

In her twenties she moved to Arizona and rode occasionally, mostly on mules. Her love for horses flared when she and Rick bought horse property and started riding regularly.

In 2007 she became the owner of "Fidla," an Icelandic mare imported from Iceland. She says that this horse changed her life and her love for "Fidla" is completely obvious.

Diana Lamb is one of those artists whose talents are very versatile. She is a superb videographer and does most of Rick's TV shows. She also does still photography, paints, and does work in fabric.

When she was younger she performed in theater arts and dance.

Rick and Diana Lamb! Their early goals were in the arts and they never dreamed of how involved they would become in the horse industry or the influence they would have upon it. But it happened. A mid-life epiphany.

The Lambs doing what they love best

Dave Ellis

Dave Ellis lives on the L S Ranch near Porterville, California. (Get it? L S Ranch! Ellis Ranch!) I really did not want to feature too many Natural Horsemanship clinicians in this book because they appear so often in public, or on television, and so much has been written by and about them. I wanted to concentrate on less prominent horse lovers.

However, Dave's story so typically exemplifies this part of the book; those who have made a mid-life career change in order to work with horses full time, that I simply had to include him.

He grew up near Bakersfield, California, in the Southern San Joaquin Valley, an area rich in petroleum, farming, and ranching. His family had horses, so he has been around them all of his life.

When he was nine years of age his mother presented him with an Hawaiian steel guitar, and that initiated his musical career. At fourteen he was playing a regular guitar and at seventeen he organized a large band which played in the oilfields.

After high school he worked his way to Bakersfield, a renowned country music center, virtually the Nashville of the far West, but it was the early Rock and Roll era, and that was mostly the music he played. Years later he would also do country music. He played dinner houses until the late eighties.

In 1968 at twenty-five years of age, he went to work for Occidental Petroleum Company. They trained him in engineering and petroleum technology and he worked his way up to International Systems Supervisor. Then, after a decade with Occidental, he left to form an independent international company. This work took him all over the world.

Meanwhile, he had never lost contact with horses and, at Bishop Mule Days, the world's largest mule show, in 1985, he met Pat Parelli who at the time was struggling to establish his reputation as a horsemanship clinician. Parelli was the organizer of the American Mule Association and in his early days was very active in mule training technology. Dave quickly

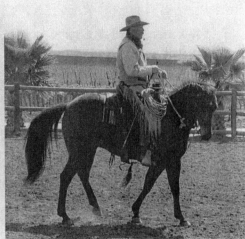

recognized the virtues of Natural Horsemanship and became a Parelli disciple.

Fourteen years later he became an official "Parelli Natural Horse-Man-Ship" clinician and in 1999 he quit his previous occupation.

Today he does about forty clinics a year all over the United States, in Canada, Australia, and Europe.

He is still a musician and often plays at his clinics which are devoted

to the training of horses and mules.

Asked about his artistic talents, aside from music, Dave admitted that he had once done a poem, had recited cowboy poetry which was usually the lyrics of his songs, had done some leather work and had designed the home in which he lived.

Importantly, he admitted to being a good dancer, but added, "it's not a passion."

Karen Scholl

Karen Scholl draws, paints, and sculpts. So, there! She's an artist. She is also one of the busiest Natural Horsemanship clinicians in the U.S.A. Based in Arizona, she travels the land, doing horsemanship clinics for women, who are the most numerous attendees at most such clinics anyway.

Horses were always her hobby and she holds a degree in Equine Science, but she ended up as a project manager in the semi-conductor industry.

Then, in 1989, she saw Pat Parelli work. She joined his organization, and mastered his progressive techniques. Eventually, she became an independent clinician and today has become an important part of the Revolution in Horsemanship. It was the Revolution that gave her the opportunity to work with horses full time, an interest that was not possible, or at least practical earlier.

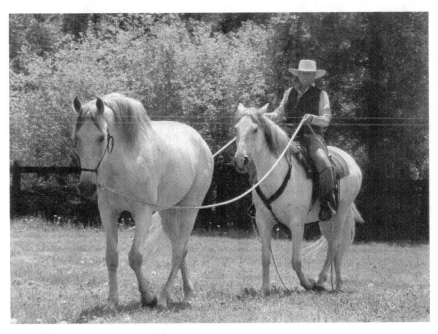

Cile Banks

When Lucille Banks ("Cile") was married to Rocky Mountain rancher Ken Jones, she became aware of my foal training program which is ideally begun immediately after the foal is born, during its imprinting period. This is when this precocial species locks onto whatever it sees moving near it and visually bonds with that thing and is motivated to follow and trust it. In nature, of course, that is going to be the mare, the foal's dam. However, in domestication the same imprinting phenomenon will occur regardless of <u>what</u> or <u>who</u> the foal sees moving.

Cile, a clinical psychologist who majored in psychology and terminal illness counseling in college and studied postgraduate behaviorism, saw the logic and practicality of my foal training concepts and applied them, with great success, to the ranch's horse breeding program. Eventually, Cile and Ken invited me to do seminars at their ranch, which I did for several years.

Cile grew up with horses. She rode but did not get involved with horse shows.

As a student she was impressed by how strongly experimental rodent's behavior could be shaped. She has had a varied career which has included being a flight attendant for Delta Airlines and managing an antique shop in New Orleans.

There was no contact with horses after she completed high school.

She earned a Master of Science degree in counseling psychology, and end-of-life patients taught her a message which eventually led her to a career change. They told her: "I wish I had done in my life what I enjoyed the most."

After serving an internship, she was hired by a mental health service to counsel sex offenders.

An animal lover all her life, she says she was so hooked on Disney animal movies when she was young that she calls it "The Disney Disorder."

Today she is a farm manager for a cutting horse facility. She imprint trains all the foals. The farm takes in outside mares for foaling. She scuba dives with dolphins when time permits. She is now working with her own Irish Warmbloods as well as the farm's horses.

Cile Banks working with newborn foal

She says that my book on Imprint Training "was a revelation" to her and that the work she did with humans earlier in her career gave her an insight into human behavior.

To my somewhat dismay, she insists that she absolutely has no artistic talent of any kind. Perhaps, she is "the exception that proves the rule" rather than a contradiction to my theme in this book; being a horse lover is linked to artistry.

It also occurred to me that of the three qualities that characterize most horse lovers, the nurturing instinct, artistry, and appreciating

challenge, perhaps Cile has an over abundance of the first and last named qualities, making the artistry superfluous.

She _is_ a complete animal lover to the extent that she raised a tiger cub to maturity in her home. And, she must like challenge. Counseling sex offenders is a job most women would find difficult.

Chapter

4

Horse Lovers Who Recognized Their Passion in Childhood

The Author

I can identify best with the people in this chapter, who recognize their passion for horses early in life and decide to make a career of it. The only problem I had was trying to decide how to do it.

Because I could draw at an early age, friends and relatives told my parents that I ought to become a commercial artist. They didn't notice that all I ever drew was animals.

Later, in grade school, I was a star English student (even as I flunked every math course I took). Again, my parents were urged to encourage me to become a journalist. Again, I wrote mostly about animals.

By age twelve my hero was Carl Akeley, the great naturalist who explored Africa, collected specimens for the nation's greatest museums of

natural history and developed taxidermy into a fine art. I read and re-read his books endlessly and dreamed of doing what he did.

At fifteen years of age, and slightly more realistic, I had decided to become a dairy farmer, own Jersey cattle, and work the farm with Percheron horses. I started working with horses and cattle on summer jobs, and how I could ever pay for a farm never occurred to me.

When I was seventeen, in 1944, my thoughts were entirely focused on the war and my imminent military service as soon as I finished high school.

The National Ski Patrol was screening applicants for the U.S. Army, recommending appropriate individuals for the Tenth Mountain Division which was fighting in Italy (and suffering record casualties to my mother's consternation). I applied and eventually received a letter recommending that, when I had completed infantry basic training, I be transferred to Colorado to the Tenth Mountain Division training center. I wanted to serve in that division for two reasons: the army no longer used horses, but the Tenth Division extensively used mules. Secondly, the troops were taught to ski and I had always wanted to do that.

Once I was in the army, we trained for the invasion of Japan, attacking fake villages with Japanese style buildings and actual Japanese tanks in the streets. We were told to expect a three year campaign and that a third of us would not return home.

However, the atomic bomb brought the war to a sudden end and I was sent to Europe to serve as a completely unqualified and untrained criminal and war crimes investigator in the Army of Occupation in Germany. I was only nineteen, but I took my job seriously and considered a career in police work.

Then, because our community did not have a German attorney free of Nazi party affiliations, I was made a court prosecutor. I won four cases in a row and actually thought of law school.

But then, I lost a case, and a very guilty man went free. I couldn't handle that.

I came home in March of 1947 and planned to start college that Fall. After a couple of weeks at home in Tucson, Arizona, I went to see California for the first time and spent the summer as a horse wrangler on the immense Irvine Ranch in Orange County, which was then an agricultural paradise.

In September of 1947 I became a student at the University of Arizona's College of Agriculture, with a major in animal husbandry. Some time that year an idea hit me like a bolt of lightning. I ought to study veterinary medicine! I probably got the idea because one of my professors, Dr. William Pistor, was a veterinarian. He taught a required course in introductory veterinary science.

If I were a vet, I could work with horses. They were a disappearing species at the time, but if I located in a ranching area, I would always have horses to work on. Importantly, I could earn enough to someday own a horse ranch of my own.

From that moment on I never deviated from my goal. I was twenty-one and finally knew where I was headed. It took nine more years before I achieved that goal. In my final year of veterinary school I met a sweet, kind, pretty girl who was to become my life partner. Colorado State University had the nation's champion intercollegiate rodeo team and Debby was the top barrel racer. Horses were her passion. We met at a college rodeo and have been together ever since.

Prior to starting veterinary school, a rancher I worked for encouraged me to go to Colorado Springs to see if I could sell some cartoons to the **Western Horseman** magazine. I had cartooned my way through every class from kindergarten through college, plus the army and every job I had ever had, but I couldn't imagine anybody paying me for a cartoon. However, the **Western Horseman** bought all of my cartoons and that was the beginning of a profitable hobby I pursue to this day.

A few years later the same magazine bought an article I wrote while I was in veterinary school. It was the first time I had been paid to write and it began a second avocation of writing for many publications and authoring many books. So, in a way, the friends and relatives who encouraged my parents to steer me into a career as a writer or as an artist were right. However, these things were always spare time activities and the care of animals, especially horses, consumed most of my professional time, as well as my recreational hours. I could not have had a happier life.

Author with a buckskin colt he imprinted at birth

First ride on an imprinted mule colt. It was uneventful.

At the desk, cartooning

"All right! So I gelded the wrong horse! I've never seen such a fuss over $125!"

Next to his saddle, a cowboy's most
treasured posession is his boots.

Nancy Nunke

If I were younger and had the time for such a project I would do a book entirely about Nancy Nunke rather than this brief inclusion in a chapter about people born with the instincts and talents to become great horse trainers.

In the course of my veterinary career I have known many incredibly talented animal trainers. Included were circus stars, movie and TV trainers and world class horse trainers in every conceivable discipline. My clients have included dolphin, elephant, lion, tiger, chimpanzee, bird, dog, and everything else you can name trainers. But, I have never known a person with greater inborn animal training aptitude than Nancy Nunke. It amazes me that she has not received the recognition she deserves. Perhaps this book will help.

Nancy was born in a small town near Toronto, Canada. As a child, animals were her best friends. When she was three years old, her aunt and uncle boarded a horse which had killed a man. The horse was kept in a locked pen and no contact was allowed with him while the courts decided whether or not to have him destroyed. Feed was thrown over the fence.

Little Nancy crawled through the fence and was found sitting between the horse's hind legs, playing with his tail. She was ordered to come out of the pen and remembers this incident as her first animal contact. Her father had been severely injured when a team of horses ran over him while he was cultivating a field, so he did not want his daughter to have any contact with horses.

A bright student, she was allowed to take college courses while she was in high school and graduated at only fifteen years of age from an accelerated program.

Because of her passion for horses she left home, got a job as a paralegal, and bought a horse. Her boss cosigned the loan.

Nancy's love for animals wasn't limited to horses. When she was nine she trained an aggressive Irish Setter for a neighbor. The dog was

kept chained and was considered dangerous. Nancy would stop on her way to school to play with the dog. She avoided his aggression by walking backwards toward him. Natural Horsemanship followers will recognize and understand that this as a non-predatory technique which can abort aggression or flight. I once got within fifteen feet of two mustang stallions in the wild by dismounting my saddle horse and walking backwards toward the stallions, stopping and retreating a few feet every time they looked alarmed.

Nancy has used that technique ever since on many different species of animals.

Her neighbors brought her all kinds of animals to care for which were injured on highways. These included skunks, crows, dogs and even a snake. She learned to suture wounds with a needle and thread. She trained her own dogs and her mother said, "Nancy can do anything with animals."

Her first paid job was to serve as horse martial in a parade. A horse with a child aboard reared up and went over backwards, but Nancy grabbed the child and pulled her from the saddle in time to save her. The grateful parents gave her the horse to train.

In her twenties, Nancy started a miniature animal show that entertained at shopping malls. The act included geese, ducks, pygmy goats, sheep and a cow, a one and a half pound Yorkshire terrier, and, for the grand finale, a full grown cougar. All of these creatures were trained by Nancy.

She had no formal training or mentor of any kind except that, at eighteen, she subscribed to and devoured Professor Beery's mail order horse training books. The Ohio horseman's books are still available today (*Professor Beery's Illustrated Course in Horse Training*, Pleasant Hill, Ohio).

Soon Nancy purchased an Arabian mare and showed her successfully. But, her earlier dreams of being a cowgirl soon led her to switch to Quarter horses. She taught her show horses all sorts of tricks

and soon realized that more profit can be made selling trick horses than show horses. She also supplemented her income by breeding and training dogs, and selling her artwork.

What kind of artwork? You name it. She paints, draws, sculpts, does three dimensional work called decatauge. She carves wood, designs clothing and jewelry, plays the guitar and the piano, loves to dance and makes leather hat bands.

In her mid-twenties, Nancy took on the challenge to train and subdue an extremely aggressive and dangerous zebra stallion. Unsuccessful, she went to a game park that had a herd of zebra and she observed them daily for two months. Observing their means of communication, she learned their body language and their complex vocalizations which she is able to imitate with uncanny accuracy.

She learned something that she preaches today:

"Horses <u>should</u> be trained the way zebras <u>must</u> be trained."

In 1993 she met David Nunke, an American. They married six months later and established Spot n' Stripes Ranch near Ramona, California, a quaint rural community in the hills east of San Diego.

The ranch raises miniature horses averaging about fifty head on the place. This supports the horse rescue program and the zebra research project. There are thirty head of each on the ranch, plus a variety of other equids including rare Caspian horses, Paints, donkeys, zorse and zonkey hybrids.

The Nunkes joined zebra organizations and are active in the International Zebra, Zorse and Zonkey Association (IZZZA.com).

Allen Pogue, the trick horse trainer featured elsewhere in this book introduced me to Nancy at a horse expo in California. When she told me that she had a herd of imprint trained zebra gentle enough for children to ride, I was frankly dubious. Why hadn't I heard of her? I am in contact with the entire horse world. I had worked with zoo and circus zebras and every one I had experienced was vicious and dangerous. I had even

imprint trained one newborn zebra and knew people who had trained hybrid zorses. My own experience caused me to be skeptical about Nancy Nunke's claims.

She sent me a photograph of one of her zebras being ridden by a lady and I used that picture in my last book, *Natural Horsemanship Explained*, in a chapter on light hands. I decided that, if I ever got down to San Diego again I was going to visit Spots n' Stripes Ranch.

In 2007 the Ramona area was devastated by a huge wildfire. I telephoned the ranch to find out if they had been spared. Nancy Nunke answered the phone with a cheerful, sprightly, "oh, hi Doctor Miller. How are <u>you</u>?"

"<u>I'm</u> fine," I answered, "but, I was concerned about the fires. I guess you're okay?"

"Oh, sure," she answered, "we lost everything on the ranch; the twenty stall barn, our home, all my artwork, everything we own, even my husbands wallet, but, thanks to my neighbors we saved all the zebras, the miniatures, and the horses. We evacuated and we survived."

The story of this fire and how Nancy directed the evacuation and how her superbly trained animals cooperated is unforgettable. Miniature horses were stuffed into automobiles and jumped on command into truck beds far above their heads. Zebras, Caspian horses, and assorted other equids were crowded into trailers and vans. The incredible story is on the ranch's websites "Zorse.com" and "Spots n' Stripes Ranch.com" and is guaranteed to make your hair stand on end.

In December of 2008 I finally had to go to San Diego to attend the annual convention of the American Association of Equine Practitioners (AAEP). Debby and I went a day early in order to visit the burned out ranch. The staff was now housed in trailers and the stock in temporary corrals. Sadly, the insurance policy came up vastly short of the actual damage, but despite the stress of the tragedy, the Nunkes, a remarkably positive upbeat couple, were as cheerful as ever.

I will never forget that day, the remarkable results Nancy Nunke has achieved in training her difficult subjects, and her level of expertise. I learned that she holds training clinics at the ranch and that they are attended by animal trainers from all over the world.

Since my greatest interest is in equine behavior, I can only hope that Nancy achieves the prominence that some of the Natural Horsemanship clinicians have. I want this not only for the gallant Nunkes, but for all the horses and horse lovers in the world.

Nancy with miniature stallion (Photo credit: Tim Flach)

Nancy with Zintawa

An example of Nancy's photography

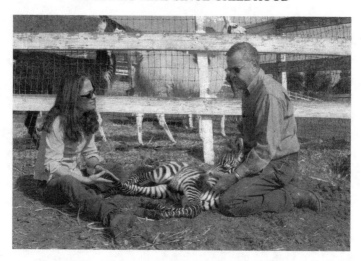

Nancy may be the best zebra trainer in the world, but she is not the only person to have imprint trained zebras at birth. Here is one that I did.

Fig. 122.—The mountain zebra.

I did some interesting breaking in of zebras at the Zoological Gardens last March. The first animal I took in hand was Jess, a Grévy zebra mare, which was about nine years old. She stands nearly fifteen hands high and is a very powerful animal. The first problem was how to get a head-stall or halter on Jess in her loose box. A peculiarity about zebras is the extreme sensitiveness of their ears, in which respect they are entirely different from the normal horse. In South Africa and on the Rus-

Nor is she the only trainer of mature zebras historically. Here is a page from Horace Haye's book showing him riding a zebra in the 19th century.

Buster McLaury

Although the few men who started the Revolution in Horsemanship before and after 1980 were working cowboys, the people who joined it subsequently were not all from that background. One that was is Buster McLaury, a lifetime Texas cowpuncher.

He was very skeptical about Natural Horsemanship at first. It was so different from traditional Southwestern methods of starting horses under saddle, and training them afterward. But, in 1984 he watched Ray Hunt perform at the Four Sixes Ranch, and realized that there was a better way to do things.

In 1996 he was running a ranch in the Texas panhandle, and got the opportunity to hold his first public clinic. It wasn't too long before he had created a new career for himself. I had the privilege of watching him do a live horse clinic a decade later at the annual convention of the American Association of Equine Practitioners, a veterinary conference attended by veterinarians from all over the world.

I thought Buster would be a good person to mention in this book, so I interviewed him. One of the questions I asked was if he had any artistic talents.

His answer was interesting. He said that most of the full time cowboys in cow country have some sort of creative ability. Some braid leather and make tack, others write poetry or draw pictures.

Buster himself is a skilled photographer. A lot of his work has been published. He has also written magazine articles and cowboy poetry. The pattern is consistent. There is a link between artistry and the love of horses. It is beyond coincidence.

Cynthia Kennedy

My first video on imprint training was produced by Palomine Productions in 1986 (*Imprint Training of the Newborn Foal*). That encouraged Western Horseman Publications to publish a book on the same subject which popularized the training method internationally.

By 1990, I had learned so much more about the learning potential of newborn foals, much of it from trainers and clinicians who were experimenting with it, that I decided it was time for a new video.

In 1995, I received a telephone call. "I'm Cynthia Kennedy. Patrick and I own Video Velocity, a company that produces horse videos. Would you like to make another video on imprint training?"

"Yes!" I replied, "and I've had my wife making home videos on the new and improved procedures I have used on my own foals. All we need to do is organize the tapes and narrate them."

"Oh! We can't use your home videos. We are a professional company. We'd have to do all the videography ourselves. What we'd need to do is go to a Thoroughbred farm for a week during foaling season, and make the video from scratch."

I responded, "I can't do that. I don't have the time. I know our own videos are amateurish, but all the information is there. It would have the same teaching potential."

Cynthia said, "no. We couldn't do it that way. We'd need a week at a breeding farm, but we were afraid you were too busy. Monty will be disappointed."

"Monty who?"

"Oh, Monty Roberts. Didn't I tell you that he offered to use his farm? Flag-Is-Up Farm has imprint trained hundreds of their Thoroughbred foals for several years and were anxious for you to use their next foal crop for a video.

"Wait a minute," I said. "That changes everything. Monty's foals

have been so successful. Yes! I'll do it!"

So, Cynthia and Patrick Kennedy, and Debby and I moved onto Flag-Is-Up in the Spring of 1995 for eight days. We had three hundred mares lined up and ready to foal that week on Flag-Is-Up and on a neighboring Arabian farm, and the video, *Early Learning* shows imprint training in both breeds and in one of Pat Roberts' Quarter Horse foals as well.

This was the beginning of a friendship with the Kennedys. We have traveled together in the horse world, enjoyed their company, admired Patrick's expertise as a producer and videographer, and Cynthia's as a director. In the ensuing years Video Velocity made two more videos for me, *Understanding Horses* (1999) and *Safer Horsemanship* (1999).

Cynthia Kennedy's life with horses began as a small child with weekly pony rides at a rental stable. She remembers how she refused to take off her cowboy boots when she got home. Her childhood movie heros were Roy Rogers, Gene Autry, and Annie Oakley. That was so pervasive in the youngsters of that generation, and, they were "good guys."

By the time she was in the fifth grade in Phoenix, Arizona, she was a volunteer dude wrangler, unpaid except that she got to ride free. The next year she finally had her own horse and kept it at a boarding stable.

In 1970, she graduated high school and started college as an art major.

Art? I thought it was <u>horses</u> she loved! Yes, she's an artist. She draws and paints, etches glass, paints on porcelain, is a good dancer, and has played the piano since the age of nine. She does the artwork for all of their video covers. What a surprise!

In 1976, Cynthia and Patrick had their own home and their own horses. She competed in endurance racing, jumping, and dressage on a half Arab. Cynthia met Pat Parelli and Linda Tellington-Jones and they introduced her to the Revolution in Horsemanship.

Patrick began his video production business in 1979 and the next

year he and Cynthia taped the Snaffle Bit Futurity. Pioneers, for several years they were the only people professionally taping major horse events. By 1983 Video Velocity had become their full time vocation.

They still own three horses at their home near Virginia City, Nevada, a colorful old mining town which was the site of the fabled Comstock Load silver ore that changed the value of silver all over the world.

"Our horses are our family," says Cynthia. "If we ever build another house the horses' quarters will be right in our home. We trail ride and love to school our horses."

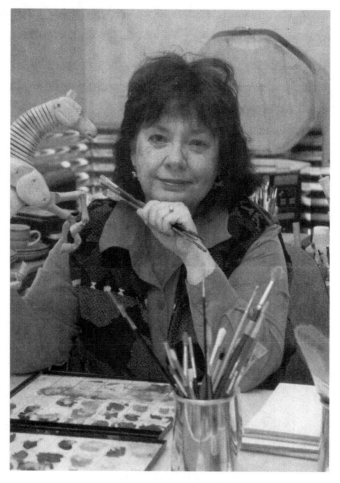

Cynthia Kennedy the artist

Virginia City is known for its wild mustangs which live around the town, wander into it, and onto the Kennedy's property.

The Kennedy family also includes Australian Shepherd dogs and they are active in agility trial competitions.

Video Velocity's excellent productions have included the horsemanship techniques of such esteemed trainers as Bob Loomis, Al Dunning, Carole Fletcher, and Linda Tellington-Jones.

Cynthia Kennedy and Patrick, like everyone else in this book are horse lovers, and artists.

In the mid-seventies, Cynthia Kennedy discovered porcelain painting. It has become her favorite medium and she has sold some pieces for thousands of dollars.

A pinch of capriole;
One dram of fresh levade,
A sprig of new-mown balotade,
And lest we do forget
A cup of purest white courbette.

Into a stirrup cup do mix
These myrrhs of haute ecole
And offer them to one whose hide
Is dark as Satan's soul.

Then magically they will transform
The colt who quaffed this jar,
Into the pearly wondrous Stallion
Of the land of Lipizza!

On one Ming jar she wrote the above poem.

Rod Bergen

Although his family had a ranch in Texas and included pioneers and Texas Rangers, and he was exposed to horses as a youngster, Rod Bergen acquired a degree in electronic engineering and ended up as a senior research specialist in the aerospace industry.

His daughter got involved with horses and this led him back into equine activities. For a decade he was a volunteer park mounted patrol member. Then he got invited to join the Los Angeles County Sheriff's Posse. He went through their academy, became a star student, and ended up as an instructor. Later he became an instructor at the Pierce College Equine Science Department Extension Program in the San Fernando Valley and teaches at other schools.

Soon horses dominated his working life and he gradually began to hold clinics until teaching and instructing became his principle mission in life.

Now the owner of seven horses of his own, he says he is a happy man and is deeply involved in a study of equine behavior which combines his technical knowledge with his equine experience. Rod is probably best known for his "bomb proofing" clinic, designed to make horses implacable and indifferent to all kinds of frightening stimuli including gunfire, explosions, raging mobs, helicopters landing nearby, etc. Originally designed for police horses, such training obviously also provides safety and security as well as peace of mind for the pleasure rider. Many casual trail riders now take his courses.

Asked if he had any artistic talents of which I was unaware, Rod bombarded me.

"I play the classical guitar and was in a band for many years. I also play harmonica."

Isn't it interesting, and probably significant, how many clinicians are also musicians? It is beyond coincidence. I can't read music, but I too can play the harmonica, picking out any tune by ear. I was a pretty good

dancer too and used to call square dances.

I told Rod, one of the last horsemen I interviewed for this book that, in addition to music, dancing was a very common skill in horsemen.

"Oh," he said, "I was always a good dancer. I loved the "Twist" and won some local competitions. A good horseman is rhythmic and must get with the rhythm of the horse. A good horseman can detect rhythmic changes in the horse before the change in motion occurs."

He sites Chris Cox as an outstanding example of such a horseman. As I said elsewhere in this book, I have seen Chris dance at a party and his animation and gyrations are a spectacle to behold. I just hope some Hollywood producer doesn't steal Chris away from the horse world.

Rod Bergen is a profound thinker. He observes that "the horse has spirit which has changed the history of mankind."

Rod Bergen in the hills of Southern California

Most important, he states, "I believe that people who are serious about horses and want to interact with them can't use confrontational methods. We so often use such methods with people, but that rarely yields best results. So learning the best ways to interact with horses can change us for the better and facilitate our human relationships. Aggression and deception are not part of Natural Horsemanship and shouldn't be in human relationships."

That sums it up. That's why, in our book *The Revolution in Horsemanship*, Rick Lamb and I used as a subtitle, *And What It Means to Mankind*.

Chris Irwin

Sometimes the choice of a career in music or a career with horses poses a dilemma for a young person. At nineteen years of age Canadian Chris Irwin, already a successful singer, song writer and musician made the difficult choice. He had run away from home and a difficult family situation at seventeen and discovered the horse industry at a racetrack in Seattle. It was 1979 and horses were to be his primary focus, despite his talents in music, drawing, painting, and as a writer.

It must not have been an easy decision because he had been an award winning teenager as a musician and as an athlete in track and field and rowing.

After his racetrack jobs he found a place driving draft horses. In 1983 he went to Nevada to buckaroo. By the early nineties he was making a reputation as a colt starter in the Reno/Tahoe area.

Then he decided to concentrate on English horsemanship. After seventeen years in the United States, Chris moved back to Canada. He was motivated to do this for two reasons: one was Canada's health care system which he felt assured medical care for his young family. The other was a decision to reinvent himself. The revolution in horsemanship was well

established in the United states, but there was not yet a well known clinician in Canada. Secondly, most of the early U.S. clinicians were Western horsemen. Chris Irwin decided to become an English horsemanship clinician utilizing the principles of Natural Horsemanship. He hoped to emulate the success of Americans like Ray Hunt and Pat Parelli, but he was strongly influenced by the techniques of Sally Swift.

In 1998 his first book, *Horses Don't Lie*, was published in Canada and it became a national best seller. Two years later it came out in the U.S.A., and again it did very well.

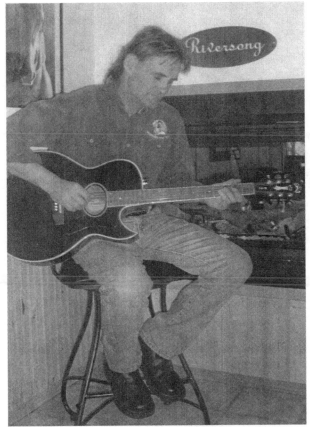

Chris Irwin musician

His name known and his reputation established, Chris went on to become a very successful clinician, concentrating on the niche in the industry he had wisely selected, English horsemanship, although his audiences now includes Western riders as well.

By 2001 he was becoming popular internationally and he now does clinics in Europe four times a year.

His artistry is expressed in his music and his prose. Much of his time and talent today is devoted to helping handicapped people.

Chris Irwin horseman

Paula Knickerbocker

One of my most loyal fans has been Paula Knickerbocker, attending my seminars and clinics whenever she can, all over the country as well as

abroad. She is the epitome of the lifelong horse lover, engaged in the industry her entire life, riding, driving, training, showing, and breeding all kinds of horses.

I had no way of knowing if she had any artistic talent to accompany her love of horses to verify my contention that the two are linked. So, I asked.

"Sure!" she agreed. "Horses are my life. Music is my therapy. Jazz! Classical! Whatever! I play the piano. I play the harp. I like to draw, too."

Why wasn't I surprised?

Paula Knickerbocker driving a four-up team.

I am going to include part of a letter Paula wrote to me because they express so well what it is that motivates her love for horses. These are the words of a woman whose life is committed to the animal she loves:

"My horses are my rock; I love them because they are honest; it is such a great feeling to go into the pasture, and they come to you, as if you were one of them. It is all about love, language, and leadership, in equal doses. Rhythm, relaxation, retreat . . . let your idea become their idea . . . follow the feel, timing, and balance, as Tom Dorrance has written about. I am so happy about the Revolution in Horsemanship . . . thank heaven for you, and the others who are showing the world that there is another way, other than fear, force, and mechanics. It is now all about psychology, communication, and understanding. I am now a true advocate of the Natural Horsemanship . . . totally committed and loving it! I have fun with my horses, and they have fun with me, and enjoy my company. A great feeling, as it is sincere."

Wylie Gustafson

I met my colleague, Dr. Raymond Gustafson of Conrad, Montana, long before I discovered his son, Western singer and musician Wylie Gustafson.

Wylie grew up on the family ranch, riding over 10,000 acres, and helping with the hard work involved in ranching in the Northwest.

"The good part," he says, "were the horses." His dad played the guitar, and wrangled dudes when he was young. He authored very absorbing books when he was older, so Wylie's artistic leanings are not surprising. He started singing and playing rock music in high school. He says he was a "cheap bass player" in his brother's band.

After two years of college at the University of Montana, he and three other college boys went professional full time, mostly playing bars in Northern Montana.

Then, in 1997 he attended the Elko, Nevada annual cowboy music and poetry gathering and, he says, went through an epiphany. His cowboy background exploded and today he is one of the most popular, energetic, and vibrant Western singers and yodelers around.

For a decade, he had little contact with horses except when he went home to help at roundups and brandings.

He married Kimberly, a young woman from the Palouse country of Washington state, where they live today. Kimberly got involved with cutting horses, but for six years Wylie just rode "regular" horses. Then, he, too, got the cutting bug, and he has been involved in that sport ever since.

Wylie Gustafson Horseman and musician

Wylie's observations are significant, especially when the link between artistry and the love of horses is considered.

"Horses were a hugely powerful influence on my life when I grew up. I hope that comes out in my music."

When discussing the art/horse connection he noted that his favorite cutting horse trainers are "creative individuals who can figure things out."

However, he added that he believes anybody can become a proficient horseman if they have humility and determination.

"Sometimes," he observed, "people like that get better than people who have natural talent, but aren't as determined to learn."

Wylie Gustafson Musician

Diane Barber

In 2006 I was one of the speakers on a horseman's tour of Spain and Portugal and it was there I met Diane Barber. She had been in Spain before, and, as an admirer of Spanish horses and horsemanship, she has trained at the Royal School there.

It was her father who introduced her to horses as a child in Pennsylvania and Diane has had a lifelong love affair with those animals.

She acquired a college degree in interior design. As a child she

loved to draw pictures, a familiar theme in this book, and she majored in art in high school.

For many years after her schooling ended she was separated from horses, but after moving to California, she resumed her involvement. Her half Spanish Arabian gelding, Jesse, suffered a serious lameness and it was

feared that he would never be sound again; but, with stem cell therapy, he made a complete recovery.

Similarly, Diane has recovered from a fall from Jesse which fractured her leg in seven places. After limping around for a couple of years, Diane, like Jesse, is going sound again.

She makes her living as an interior designer, specializing in equestrian themes.

A music lover, she attends symphonies and listens to music frequently.

Her horse, she says, is her "Spirit Guide." Horse lover! Artist! Inseparable qualities in certain people!

Diane Barber

INTERIOR DESIGN FOR EQUESTRIANS

EQUESTRIAN™ *designery*

Equestrian Designery · A Full Service Interior Design Studio · ASID
Rolling Hills Estates, California · 310.544.1798 · equestriandesignery@mac.com

Richard Winters

Most of the clinicians involved in the Revolution in Horsemanship elicit varying responses in their audiences. Lots of people like them. Some people revere them, becoming blind disciples with an almost religious zeal. Other people revile them. I have heard some people say of the most talented and successful clinicians, "I can't <u>stand</u> him (or her)!"

There is only one clinician of whom I have <u>never</u> heard anybody say they don't like. They may prefer someone else, but they will accept Richard Winters. I don't know if it is his amiable manner, his experience as a preacher, or just some undefinable quality to his character, but Richard is just a nice guy that everybody seems to like. So do the horses.

He loves animals, but for him horses have always had a special fascination. It was there when he was a kid. He never wanted to be a fireman, a cop, or warrior. He just wanted to be a cowboy and ride horses. Not until he worked for California trainer Troy Henry, who was such a great influence on Pat Parelli, did he own his own horse.

Like most of the Natural Horsemanship clinicians, Richard has made some very good videos and I think the trailer loading portion of his video, <u>Foundations</u>, is the best I have seen on that subject.

Of course, when I interviewed him for this book, I asked about his artistic ability. I knew of none despite our friendship of many years. I have even done clinics together with Richard.

So, I was surprised when he told me that he has always been a singer, was involved in four part harmony as a schoolboy, and was a guitarist.

See?

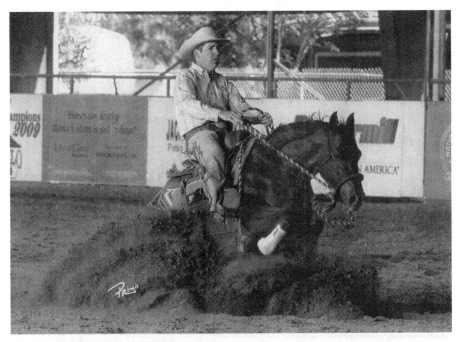

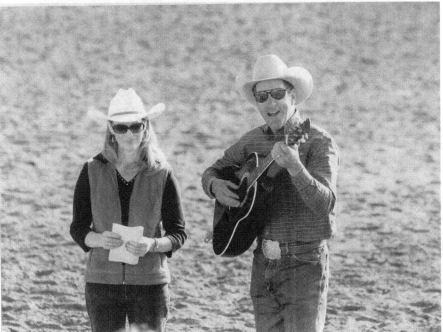

Richard Winters horseman and musician

Mark Rashid

Colorado has a disproportionate share of natural horsemanship clinicians including Pat Parelli, Marty Marten, John Lyons, his son Josh Lyons, and Mark Rashid of Estes Park. Mark was not raised on a ranch, but was attracted to horses as a boy and spent a lot of time at a neighboring stable. I have attended his clinics and he does a good job with horses, but that's pretty much all I knew about him, so I asked, "do you have any artistic abilities?"

He said, "yes. I am a drummer and I play the guitar. I still play in a band. I've written several books. I draw pictures."

There you are!

Mark said that one of his contemporaries, Harry Whitney, a well known natural horsemanship clinician was an excellent photographer. "He's an artist with a camera," he said.

We should not be surprised that so many of the clinicians involved in the Revolution in Horsemanship have artistic talents. Frank Bell plays the harmonica, loves to dance, and has painted. Brad Cameron has made saddles, done floral leather carving, and is now involved in artistic

photography. Canadian clinician and ex-champion rodeo bronc rider, Mel Hyland, is a talented singer and guitarist. Buck Brannaman has been a trick roper since childhood and watching him work with a lariat makes one appreciate that it is an art form.

When I asked the popular clinician, Chris Cox, about any possible artistic talents he confessed to writing poetry. Also, having observed him at a ranch party once I can attest to his acrobatic dancing skills. Chris said, "to become an effective horseman you <u>must</u> have creative skills. You must also be determined because horses will challenge you and they can humble you."

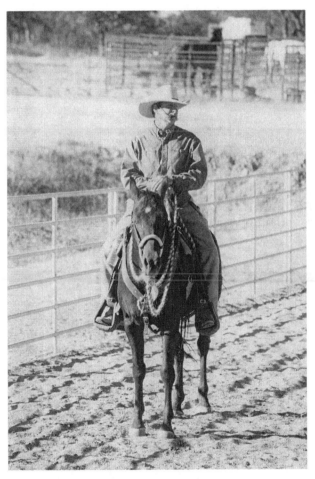

Mark Rashid horseman, musician

Meredith Hodges

I already knew of Meredith Hodges' total devotion to mules. I mainly called her to learn if she had any artistic talents to support the thesis of this book. I knew that her father had been cartoonist Charles Schultz ("Peanuts").

I knew that she was obsessed with horses as a little girl and that this obsession had never subsided. I knew that her mother loved mules because, thirty years ago, I had bred two of my mares to one of their family jacks in Northern California in order to produce the first two mules we raised.

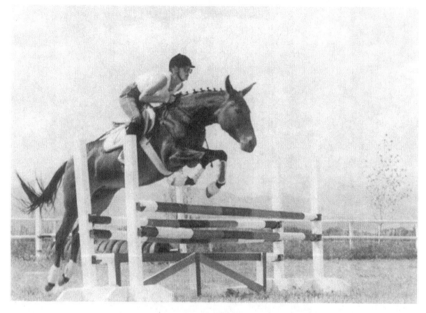

I knew that Meredith had moved to Colorado in 1980 and had devoted her life to horses and mules. She is probably the world's leading mule advocate and has produced videos, poems, stories, books, photographs, drawings and TV shows all about mules. Jasper, the cartoon mule of song and story, was her idea.

So, I really didn't need to ask if she had any artistic talents. I just wanted to make sure that I didn't leave anything out. But, I nearly did. I learned that her showplace ranch in Loveland, Colorado, is what it is

because she designed the architecture and the decor.

Horsemanship and art: it's inseparable.

Mule lover Meredith Hodges

Harold Wadley

Shortly after one of my foal imprint training videos was produced I got a phone call from a Harold Wadley who lives in St. Maries, Idaho. He told me that he had seen my video and wanted me to know that it was almost identical with a method he had been taught by his grandfather when he grew up on the Cherokee Reservation in Oklahoma.

Subsequently, I learned that what I called imprint training was practiced by other native American tribes in addition to the Cherokee, including the Comanche, and the Kiowa prior to the reservation era.

It is perfectly logical that nomadic peoples, in constant contact with their horses or other domestic stock, would have the power of observation, the curiosity, and the logic to discover optimum means of communication with their animals.

Correspondence with Harold Wadley eventually led to us meeting. His profound sense of understanding horses led me to encourage him to write a book, which he did. It is not a fancy book. Done in soft cover, illustrated with snapshot photos and produced in an inexpensive format it is, never-the-less one of the best books on horsemanship I have ever read. Despite a cumbersome title, **Spirit Blending Foals Before and After Birth, An Old Way Continued** has pearls of wisdom on every page, and covers the training of a colt from <u>before</u> its birth to its first rides.

Harold was born in 1934, raised with horses used for ranching and farming. He went to high school at Berry Hill, Oklahoma. There were thirteen kids in his class. The Korean War was on when he graduated and he enlisted in the Marine Corps. He spent two winters in Korea and was wounded in combat.

After his discharge he went to college under the G.I. Bill, majoring in forestry.

He worked for the United States Forest Service until 1967, supplementing his income by starting colts for ranchers in his region and catching and taming mustang colts in the Spring.

By the time the Viet Nam War was in progress, Harold was married and had two sons, but he hated the anti-war movement and the way military servicemen and veterans were disparaged by so many Americans, so he volunteered again for the U.S. Marine Corp. After three weeks at Camp Pendleton becoming familiar with the newest weapons, he was flown directly to Viet Nam. He insisted upon going as a private first class in order to work with and help the younger personnel. In his second battle he was made a platoon commander until he was again wounded in action.

Afterwards he went to Wyoming where his wife's family lived. Again he worked for the Forest Service with a pack string for several years. He helped to establish the Colorado Mountain Trail, from Denver to Durango.

Then he went to Idaho with the Forest Service, working with ranchers leasing government land, and did a lot of packing and colt starting on the side.

The last two years before he retired, the Forest Service sent him to an Indian college in Kansas to teach range ecology.

After ranching for a while, raising horses, cattle, and Beefalo (cattle/Buffalo hybrids) he was hired by an international wildlife organization headquartered in Switzerland to go to China and Mongolia. He was fascinated by the native Mongolian horse culture. The Chinese government had displaced indigenous nomadic people and that saddened Harold, because it reminded him of the Trail of Tears when his own people had been forced to leave

their homeland. He helped the Asians with their forestry and livestock management and taught the youngsters horticulture so they could grow their own fruit.

Harold spent nine years in Asia. The last three years was for World Vision International, doing the same sort of thing he had been doing for the Swiss organization, except that this one was headquartered in Hong Kong.

The Chinese asked him to write a handbook on agro-forestry, which he did. So, *Spirit Blending* is not his first book.

Throughout this career he had horses, never losing his feeling for them. This man, born into an Indian tribe that were once superb horsemen, but who, although the reservation system greatly destroyed their culture, managed to keep their knowledge and traditions alive. But, Harold is more than a writer. He is an extraordinary craftsman, and his handmade horse gear, comprised of natural materials such as braided horsehair, wood and leather carving are absolute works of art. Weaving, braiding, carving and horsemanship; all are works of art and science.

Harold Wadley his horses and his craftsmanship

Julie Goodnight

When Julie Goodnight graduated from college with a degree in outdoor education, she had no plans to become one of the more popular and successful clinicians involved in the Revolution in Horsemanship.

She had grown up on a horse farm in central Florida and was always around horses. Her father was a Quarter Horse man, but Julie was oriented toward English horsemanship, and all through high school she competed in hunter-jumper classes.

Then, attending college in New Mexico she worked on horse farms and at the racetrack. Although she did not plan to make horses her career, her experience and ability and a lifetime passion for understanding equine behavior resulted in job offers in the industry.

A move to Colorado, which satisfied her love of snow skiing, led to

a career in the horse show business.

At 25 years of age she decided to go into business for herself at a facility in Salida, Colorado, catering to all breeds and disciplines. The potential was limited in the small Rocky Mountain community, and she had to either import business or export herself.

The Revolution in Horsemanship was under way, and she began by

holding training clinics in Salida. They were so successful that Julie went on the road. By 1996 she phased out her "at home clinics" and committed herself to doing clinics everywhere. Currently she is traveling and teaching 45 weeks a year, but still has her own horses at home in Colorado.

When I started this book, my principle theme was to be exploring the powerful passion that causes certain people to completely submerge themselves in horsemanship. I wanted to understand the source of this passion which dominates so many lives including my own and my wife's.

I was aware that many horse lovers have artistic ability, but until I began interviewing them for this book I didn't realize how universal it was. I certainly did not suspect a genetic connection which I am now positive exists in such people.

So, as I interviewed Julie Goodnight for this chapter, a person I have met socially, and observed doing clinics, I had no idea as to any creative artistry she may possess except that I knew she could write well.

Accordingly, as I completed this interview, I asked if she had any artistic ability. She replied, "you mean like drawing or painting?"

credit: Heidi Nyland
Julie Goodnight

"Not necessarily," I explained. "I mean <u>any</u> art form, whatever."

"Well," she said, "you know that I can write. I love to write, not only articles and books about horses, but creative writing of any sort."

Then she added, "I love to dance. I have danced since I studied ballet at five years of age, and I danced all through my college years. I'm a dancer."

I told her how many of the people in this book emphasized dancing, including the men, as a prerequisite for skilled horsemanship!

"It involves rhythm and coordination necessary to be a good rider," I said.

"Yes," she responded, "and understanding horses requires an

intuitive personality."

She's right. Great horsemanship requires sensitivity, awareness, compassion, and communicative powers that not everybody possesses. In order to be an effective Natural Horsemanship clinician one must also be a gifted teacher, a counselor, and a coach.

Ernie Morris

If I were to select one person to illustrate the principle theme of this book, that artistry and the love of horses are inseparably linked, I would choose Ernie Morris.

Born more than eighty years ago, Ernie was raised in the cattle country of California. He is a fifth generation vaquero, and the great grandson of pony express rider and stage coach driver Samuel S. Jobe.

Ernie and his wife, Blanche, still live on their ranch near Templeton, California where he is active in the cattle business, braids rawhide gear and makes horsehair mecates (ropes).

Not long ago I watched Ernie rope. Using a ninety foot long rawhide reata, he proved that he is still a top hand.

ERNEST MORRIS - VAQUERO ARTIST

But, it is Ernie Morris' artwork that is his lasting legacy. It was a hobby until 1964 when he became a full time artist and his work in all kinds of media has brought him honor. Nearly always, the theme of his artwork has been historical. The vaquero era and culture is preserved forever thanks to his talent and dedication.

He has authored four great books about vaqueros, horsemanship, and livestock handling; illustrated with his fine paintings: *El Vaquero* (1989), *El Buckaroo* (1995), *Riata Men* (1999), and *California Cowboy Inventions* (2003).

In addition, he has illustrated other books and articles, and has published a variety of newspaper and magazine articles.

The recipient of many awards and honors, Ernie typifies the kind of people who inspired me to write this book.

Some of things that Ernie told me bear repeating:

"Horses fulfill my life. It's all tied together."

"Great horsemen have great timing. You have to "romance" a horse like you do a lady on the dance floor."

"Good horsemen can always do other things well."

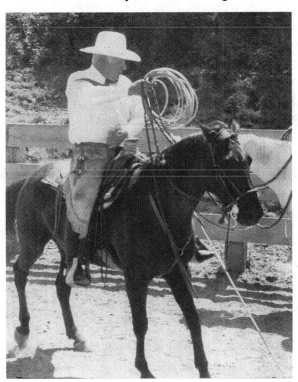

Ernie Morris

Dr. Sharon Spier

Dr. Sharon Spier is a professor at the University of California School of Veterinary Medicine.

A professed "horse nut" since childhood she begged her parents for a horse, eventually got one and got involved in horse shows, galloped race horses, rode endurance races, and worked for a polo player. All this eventually led to a degree in veterinary medicine from Texas A & M University and a career in research and teaching.

Her passion for horses has never subsided. When she is not working with them professionally, she is involved with her own horses at home.

As has happened so often when people were interviewed for this book, when asked if she has any artistic talents she promptly replied no. Yet, with persistent questioning I learned that she played the flute, the

piano, and the guitar, sang in a choir, loves to dance, took a course in photographic art, and does fine photography. She also confesses a love for Southwestern art, visits cowboy museums and Western art and cultural centers as often as possible and hangs out in art galleries.

Dr. Sharon Spiers, wisely, combined her lifelong passion for horses with a distinguished career in academia.

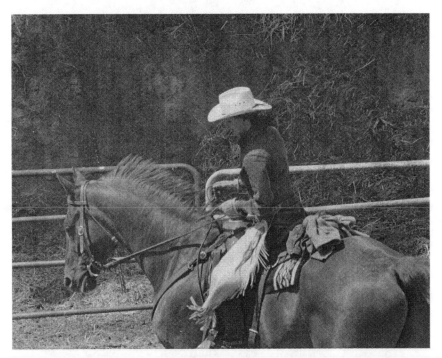

Dr. Sharon Spier

Dave Thornbury

I knew J.D. Thornbury before I knew his son, Dave. J.D. was a trick roper, trick rider, and Roman rider. The whole family participated in this and my veterinary practice cared for their horses. They moved to Calabasas, California which was within our practice territory, in 1981.

The family performed at rodeos, fairs, and wild West shows. Dave learned the art of trick roping, trick riding, and Roman riding from J.D.

Dave as a bareback rider

Young Dave also rodeoed, riding bulls, bareback broncs, and his favorite event, saddle bronc riding.

When Dave was a junior in highschool, his dad bought him a leather stamping tool kit for fifteen dollars. In the late sixties he made his first saddle and has been in the business ever since.

While he was competing in rodeo, some other contestants asked him to make chaps for them and today Dave is best known for his chaps. At first his best customers were rodeo contestants, but after Ray Hunt ordered a pair, everybody wanted Dave's chaps, including many entertainment world celebrities. So he is kept busy. But, he still has time to ride his Quarter horses with his family.

"Horses are my life <u>and</u> my hobby," says Dave Thornbury.

Dave still trick ropes professionally at entertainment events.

And as a saddle bronc rider

Discussing the frequency with which true horse lovers are also music lovers and good dancers as described in this book, Dave told me

something I had not heard before.

He knew three successful rodeo bronc riders who took ballet lessons, albeit secretly. The balance, coordination, rhythm, and lower body strength required in ballet improved their bronc riding.

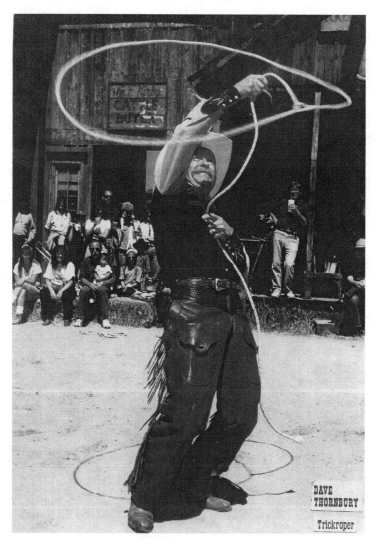

More recently as a trick roper

Dave in his saddle shop where leather is his art medium

Sharon Madere

I had never heard of Sharon Madere until I spoke at the Association of Pet Dog Trainers convention I mentioned earlier.

She is the founder and CEO of Premier Pet Products. The mother of five children, her sense of humor is obvious when one reads her business card. It states "Founder and CEO, Kid's Taxi Service and Horse and Dog Nut."

Because she is very active in the APDT, I spent quite a bit of time

with Sharon. After I got home from the convention, I decided that I would interview her over the telephone, because she typifies the personality that inspired this book.

She remembers, when she was three years of age in New Orleans,

Sharon Madere with some of her art collection; a painting and antique bits

being fascinated by horses. After she learned to read she devoured books about horses. By the time she was in the third grade her family had moved to Arizona and she began to take riding lessons.

Around thirteen years of age she came under the influence of a U.S. Equestrian team member, Rosalind Johnson who introduced Sharon to dressage and eventing. She rode many horses under her tutelage, but never owned a horse of her own until she was fourteen. In addition to her addiction to horses, she also trained neighbors' dogs.

After a spell in college, she dropped out to join a commune in Texas. She spent eight years there and during that time she was put in charge of their horses. She got involved with Tennessee Walking Horses and also raised gaited mules.

Later in life she started the Greyhound Pets of America, a rescue organization that places retired racing Greyhounds for adoption.

Eventually, a home business in pet products led to Premier Pet Products of Midlothian, Virginia. She presently owns four Tennessee

Walking Horses, but, typical of the extreme horse lover, she would like to own horses of a half dozen other breeds.

Oh, yes, the art connection: Sharon Madere draws, paints, sculpts, <u>loves</u> dancing, has a fine art collection, has sung competitively, studied drama, writes poetry, and has done interior decorating.

There you have it: the nurturing instinct, animal lover and artist, the necessary ingredients.

One of Sharon's photos taken from the back of a mustang

Dance upon a golden breeze
Listen to the sinking sun
Drink the shade of whis'pring leaves
Ride the raindrops one by one

Kiss the windswept aqua waves
Touch the crystal crescent moon
Breathe the clouds of ancient days
Sleep 'neath stars of fragrant hue

Soar on snowborne wings of ice
Dream of rivers running free
Chase the endless sands of time
Share this love of life with me

–Sharon Madere

Pat Roberts

Of all the clinicians involved in the Revolution in Horsemanship, none is better known than Monty Roberts of Solvang, California. He is constantly traveling, is well known on every continent, and his books and clinics have helped to spread a culture of kindness.

Less well known is his wife, Pat, but her life epitomizes the connection between a love of horses and artistry.

Pat started painting in 1966 when she and Monty moved to Flag-Is-Up Farm in California's beautiful Santa Ynez Valley, where they still live. The ranch house had bare walls and Pat decided that they needed to be decorated with paintings.

So, she began to paint. She took lessons, and within two years she

was selling her colorful artwork.

But, her husband is quite color blind, so he could not fully appreciate her work. Therefore, she decided to take up sculpting. It was a fortuitous decision because not only can Monty now fully enjoy her work, but Pat has become an acclaimed Western art sculptor.

Horsewoman and sculptress, Pat Roberts, at work

One of her creations is called "Join Up" and it depicts her husband at the moment of Join-Up with an unbroke colt.

When she was working on it, she noticed that somebody had altered the clay model, broadening the shoulders, and lessening the belly. After this happened again, she figured out that Monty was changing the appearance of her work when she was not around.

Recently, Monty has lost weight and now looks like the person he wanted to be in Pat's sculpture.

So much for the artistry. What about the horses? It began at age two Pat says. Although they lived in the city, they had relatives in the country so that provided equine experience. She wrangled dudes on a relatives guest ranch from age ten to when she graduated high school. (That makes her a professional horsewoman since age ten).

She didn't show much but she had a crush in grade school on a boy who was a frequent winner at the horse shows. His name was Monty

Roberts and, she says, he was disinterested in her because she was too short. They went through high school together and then she grew taller (and Monty matured as well) and they began dating just before she graduated.

Actually, Pat says she turned down Monty's first offer to date her, despite the crush she had on him. She explains that she was using the "advance and retreat" method for which Monty became famous. The method ultimately resulted in "Join Up" for the couple, as it still does for Monty with unbroke horses in the round pen. They were married in 1956.

Married, Pat started riding full time. She galloped race horses and competed successfully in horse shows. She especially loved cutting horses. It was a busy life for both of them. They often campaigned separately, on the road hauling horses over long distances.

Eventually, they started a family; two daughters and a son. They are still a close family.

Monty and Pat Roberts are still enormously involved in the horse industry at their Flag-Is-Up Farm in Solvang, California.

While he does clinics all over the world, on every continent, she holds the fort down at home. This gives her time to do her artwork.

Woodard Thomas Peer

As a child, growing up in Reno, Woodward loved the cowboy lifestyle. His mother served on the medical team at the Reno rodeo and because of that he got to meet a lot star rodeo performers. (After all, this was Reno.)

He had the rodeo bug and practiced roping with an electrical extension cord.

At thirteen he started taking music lessons and soon played in his school band.

Still in high school, he got into the Rock scene and also into motorcycles. He married a lady who was a Los Angeles police officer, and started going to church. An older farrier led him back into the horse world he had admired so much in his youth but had abandoned. He learned how to shoe horses and when his mentor died, Woodward took over the business.

Now he realized that he needed to learn more so he started studying horsemanship and resumed riding, becoming increasingly involved.

He now owns a couple of horses but he does not compete on them. He just pleasure rides and trains in the San Fernando Valley.

He is still an avid music lover but he plays for himself now and no longer professionally. Writing music and lyrics comes easily to him and when told of the connection between artistry and the love of horses he recalled that his mentor, John Hoeg, was not just a farrier. He was also an elegant ballroom dancer.

Woodward Peer at work as a farrier and astride his horse

John Hawkins

"I've always been interested in horses," says John Hawkins. His father had him riding unassisted by the age of two. The Hawkins family moved from Texas to California in 1940, in the last year of the Great Depression.

John was a jockey until he reached 120 pounds, too heavy to race. At fifteen he entered his first rodeo, and competed in rodeos until 1973, becoming one of the top bronc riders of all time. He won at nearly every

major rodeo in North America. He also worked as an extra in movies and television, including such classics as "Rawhide," "Bonanza," and "The Rifleman."

At 78, he now trains horses and teaches people how to ride at his place in Cottage Grove, California. He looks back at a lifetime spent working with horses and says, "it was something I liked to do. I had a lot of fun riding the back of a horse and I was able, with the good Lord's help, to make enough money to keep going. I've been so lucky over the years. I've met so many nice people and seen things and done things that you'd never have a chance to do now. Things I've seen since I was a little kid in the Depression until now, the changes and stuff, you can't believe."

Would a lifelong cowboy and one of rodeo's greatest bronc riders have artistic ability?

"Oh," says John, "I make bits and spurs"

Take a look at his bits. They are works of art.

John's artistry

John Hawkins on Apache, Cheyenne '65. It is one
of the most spectacular bucking photos ever!

Elinor Switzer

Although Elinor Switzer was born in Germany and has spent most
of her life there, she is an American citizen. That's because her parents,
both mathematicians, emigrated to Germany in 1973 to work and to live,
but they retained their American citizenship.

Elinor's grandad had a ranch in North Dakota and she visited him
when she was eight years of age. This was her introduction to horses and

it began a lifelong commitment.

In Europe she took English riding lessons. She decided to study veterinary medicine and did so at the University of Hannover.

In January of 2001 the young woman suffered a stroke. This resulted in a prolonged recovery. Initially she was confined to a wheelchair, but, over time she has regained much more normal function, and rides her horse regularly.

After securing her doctorate she taught, did research, and clinical work. Then she decided that teaching, writing, and publishing were her things.

Because of her stroke, one arm was paralyzed for a long time. This encouraged her to ride Western, so she now rides a Quarter horse that is neck reined.

Professionally she is now the managing editor of a human medical journal, *Thrombosis and Haemostasis*, in Stuttgart, Germany.

One of her activities now is working with disabled riders. "Horses can change lives," says Dr. Elinor Switzer. They certainly changed hers. She is president of a Western riding group, Para Western Reiter (For Western Riders), and her goal is to have classes for disabled riders at Western horse shows.

Dr. Elinor Switzer, horsewoman, writer, veterinarian

Cherie Harter

Cherie Harter was a bridesmaid at my wedding. When she and my wife and a third girl named Harriet were in their early teens, all they lived for were their horses. They spent every weekend riding. Many women will be able to relate to that.

"When I was riding everything was okay," says Cherie today. "All the problems of teenage life disappeared."

Her horse back then was "Pepper." She read a book on equine soundness, and observed that Pepper had every problem in the book. A big horse, he had collar marks indicating that he had once been a draft horse.

Cherie started college at the University of Arizona, my own pre-veterinary alma mater and the school that initiated college rodeo. She competed in mixed team tying (steer roping, head and heels, for a boy and a girl), barrel racing, and goat tying.

Then, on a visit to Northern California she met the love of her life, an aerospace engineer and a horseman, Jim Harter, and they were married a few months later, when Cherie was only eighteen.

Jim has passed on, but he could have been included in chapter two of this book because he gave up his successful engineering career to become a Thoroughbred breeder in mid-life.

He and Cherie moved to Grass Valley in the Sierra foothills of California's Sierra Nevada Mountains, the gold rush country known as "The Mother Lode." There they established the Harter Thoroughbred Farm, a small but successful racehorse operation that produced three stakes winners.

Cherie was the first Thoroughbred breeder outside of my own practice clientele to employ my imprint training technique on her newborn foals, with great success.

But all this was long ago and today she still owns one Thoroughbred mare. Her real joy now is driving her Welsh Pony and

competing in events such as Grass Valley's famous annual Draft Horse Classics show.

Despite knowing Cherie since my marriage I did not know if she had any artistic talent. So, I asked her if she did.

"Of course!"

She draws, paints, carves leather, braids horsehair and loves interior decorating.

Why should I be surprised?

Cherie and Jim driving Nessie, a Welsh pony. Driving is Cherie's current passion, and she has been very successful.

Chapter

5

The Epiphany

At the end of May each year I participate in a symposium on "Light Hands Horsemanship," together with a group of extremely talented clinicians. The event has been held on Intrepid Farms, a breeding facility in California's beautiful Santa Ynez Valley. Following the 2008 clinic a group of us were casually sitting around discussing horsemanship. I brought up my observation that I had long been aware that many talented horsemen also have artistic ability. The group showed interest and surprise.

"Take Eitan here for example," I said, pointing to Eitan Beth-Halachmy, one of the clinicians who had overwhelmed the clinic audience with his horsemanship skills.

"I know that Eitan is a skilled sculptor. He has made some beautiful creations. He is also an exceptional videographer. He has made the most beautiful horse videos I have ever seen, and the music he selects tells me about his love of music."

Everybody nodded agreement.

The art and horsemanship
of Eitan Beth-Halachmy

Then I turned to one of the other clinicians, trainer Lester Buckley, a remarkable Texas cowboy who, after achieving fame in the cutting horse world, had gone on to master dressage and become a licensed instructor in Germany, a formidable achievement.

"Lester," I said, "I've known you for eighteen years and we have become good friends, but I'm not aware of any artistic ability that you have. Do you have any?"

"I play the violin," Lester responded.

"No kidding?" I crowed. "You're a fiddler? I never knew that. I love Bluegrass. We need to hear you play."

My friend looked at me seriously.

"I don't play the fiddle," he said, "I play the violin."

Chastised, I learned Lester's music teacher told him that, unlike most of her students, he had a true ear for music.

Lester began playing the violin in his thirties. He is now composing melodies. He says that he sees a similarity in learning music to learning horsemanship. At first he mimicked others. Later he began to create.

As we spoke, Arthur Perry, owner of the farm on which our "Light Hands Horsemanship Clinic" had just been held, was standing nearby. "So," I said, "Arthur, your home is filled with an extensive collection of art. You have been a horse lover since childhood. Does your artistic taste go beyond collecting?"

"Well," he said, "I play the piano and have been a professional singer for much of my life."

I hadn't known that, and it was then that I got the idea to do this book.

Darrell Dodds, the publisher of <u>Western Horseman</u> magazine was with us. He took many photos of the event and later in the year his magazine published a fine article on it.

I asked, "Darrell, you've been a lifelong horse lover. Do you have creative art ability?"

He answered quietly, "yes, I'm a writer and you have seen my photography."

Indeed I had. Darrell Dodds photography is unquestionably an art form.

By the time I got home, the theme for this book had taken form in my mind. I would interview true horse lovers, all personally known to me. I wanted to see if I was correct that nearly all share three characteristics: a strong nurturing love for animals, artistry, and a sense of great gratification when they create a trusting bond with that fearful, flighty, timid animal–the horse–transforming it into a trusting and compliant friend.

It was a great awakening. An epiphany! The passion for horses and artistry were connected. When I got home I began contacting people whom I recognized as true horse lovers. Consistently, they also had artistic talent. I realized that I had to make this known. It would help horse lovers, including me, understand our passion and how it directs the course of our lives.

The Light Hands Horsemanship Clinic at Intrepid Farms,
Santa Ynez, California, May 2008
Photo by: Paula Knickerbocker
Bottom row, left to right:
Clinician Jon Ensign, Sponsor Tom Spalding, Clinician Eitan Beth-Halachmy,
Organizer Debbie Beth-Halachmy, Clinician Lester Buckley, Spalding Labs Chief
Scientist Bill Clymer, Ph.D, and Clinician Anne Judd
Top row, left to right:
Veterinarian Robert Miller, DVM, Clinician Jack Brainard, Clinician Dave Lichman,
Hosts Rick and Diane Lamb, Farm owner Art Perry, and Clinician Dave Ellis

Arthur Perry, owner of Intrepid Farms. He also conceived of The Light Hands Horsemanship clinics. Here he is mounted on a Morgan stallion in parade regalia as worn in the Rose Parade on New Year's Day. Art is a horse lover, music lover, and art collector.

Chapter

6

Why We Do What We Do

Why would a veterinarian choose to do horse practice? Our degree and our license enable us to work in an air conditioned office devoid of snow, rain, sleet, bitter cold, ripping wind, and roasting heat. Why do we choose to slog through mud, drive from farm to farm, cope with flies, manure, and dust? We could be treating cats and dogs on a convenient examining or operating table, assisted by a highly trained nursing staff. Best of all, in most populated areas today, a small animal practitioner has available an emergency clinic, obviating the need to make night calls and permitting a "normal" life with weekends and holidays at home. Why do we choose to do horse practice with its middle of the night obstetrical and colic emergencies, its weekend farm calls, the perpetual risk of highway accidents, and the constant emergencies disrupting our schedule? Everything we do frightens the horse, or hurts it, or both. Consequently, we are constantly exposed to dangerous situations. A frightened horse may prefer to flee, but, if it considers itself unable to flee, it will fight. Horses can strike, kick, and bite and no equine veterinarian goes through a

career without hospitalizing injuries.

Why do we do it? Even range cattle are safer patients, usually restrained in a chute or with ropes.

Most of us do it because of our love for the horse.

Why do jockeys choose to do what they do? Do you know that jockeys have the greatest risk of serious injury in the sports world? What they do is the most dangerous of all athletic endeavors.

What is the "rodeo bug?" Only the very best rodeo contestants make any money and that is a fraction of what even mediocre athletes earn in basketball, baseball, or football. Rodeo contestants must pay entry fees in order to compete in their sport. The majority end up losing money, and are often injured. Why would anyone choose this sport? Is it the excitement? Sure, but many other sports are exciting, less dangerous, and much less expensive to pursue.

No, underlying most rodeo contestants incentive is the challenge of working with or competing against animals, especially horses. Most rodeo contestants admire and are intrigued by horses.

Why do some young people eagerly seek minimum wage jobs around horses, grooming them, exercising them, feeding them, and mucking out stalls?

There are also competent older people who accept this underpaid lifestyle voluntarily. They could be working in a factory or a market and earn a better income. Horses are the reason they do what they do.

What is it that motivates some middle income people to spend every spare cent on their horses? I have had clients who forfeit their retirement income on their horses, and their children's inheritance. Otherwise intelligent people who should be investing extra dollars, spend it on their horses. Why?

Only true horse lovers can understand why so many people devote their lives and their fortunes to their horses. For such people, life is

incomplete without their horses.

Yes, many people spend more than they should on their hobbies, their sports, their avocations. Boating, skiing, sports cars, cruising, and flying private aircraft are all examples of expensive pastime pursuits, but they involve non-living objects. Horses are alive. They are living creatures which share with us the emotions that characterize life: fear, contentment, joy, irritation, energy, fatigue, and affection. We can all be attached to a motorcycle, a sailboat, a snowmobile, or a jeep, but it is a one-way bond that cannot compare with the relationship possible between two living creatures.

Chapter

7

The Misunderstood Icon

Hollywood accomplished two things with its half-century of endless Western movies. It made an internationally recognized icon of the American cowboy. It also distorted his function and character.

Back in an era when the Saturday matinee was the principal media entertainment for boys of my age, I was a rebel. I did not like Westerns. I recognize now that the reason I disapproved of them is that I was, and still am, a pathological realist. Although I have been a voracious reader all of my life, I have never been attracted to fiction unless the plot was entirely believable. Science Fiction, for example, was never my thing. Nor, was Batman. I could accept Robinson Crusoe and Moby Dick. They were possible!

So, when I saw actors firing thirty or forty rounds from a six gun without reloading, I would protest loudly. "That's stupid!" This elicited shouts of "shut up Miller, you know-it-all" from the other kids in the theater.

I also knew that you couldn't get on a horse in Denver and ride off at top speed for San Francisco. I knew that working cowboys did not wear inlaid boots and white hats, or carry guitars while riding silver mounted saddles.

With very rare exceptions, Hollywood's depiction of "good guys" and "bad guys" was ridiculously distorted.

The "good guys" declared themselves above the law, and with guns blazing and side kicks following, they spent most of their time avenging the grievances of the townsfolk and settlers.

The "bad guy," identified by a black hat, was the epitome of evil, and was either a rich land owner or an entrepreneur (is there a socialist slant here?) or one of his sadistic henchmen.

Because of Hollywood the word "cowboy" today has become synonymous in the popular press all over the world with the words "irresponsible," "impetuous," "violent," and "reckless." We read of "cowboy strategy" in international relations. President George W. Bush was accused of a "cowboy mentality," we hear of a "cowboy truck driver," etc.

Even after Western movies became a rarity, and those still being made, included foul language and sex which were absent from the movies made during the heyday era. Still, the cowboy's image was inaccurately presented.

The acclaimed movie **Brokeback Mountain** was the ultimate distortion of the working cowboy. Beautifully filmed and skillfully directed, it was the story of two cowboys who had a homosexual relationship. Although dressed as cowboys and presented as such, a cow is never seen in the movie. Instead the two are seen herding large flocks of sheep.

As a result of this Hollywood misrepresentation, the working cowboy is one of the most misunderstood occupations in the world. It is

also one of the most underpaid.

Why Do They Do It?

We understand why the post Civil War "cow-boys" who went on the long cattle drives from Texas to the Kansas railheads did it for ten dollars a month. Most were uneducated youths looking for anything to do, especially if it would help them to escape the boredom of nineteenth century rural America. "Droving" offered a chance for adventure, a chance to see something new and to escape a daily tedious work load at home. Other drovers were unemployed war veterans and freed slaves. They spent long months on horseback droving wild cattle, fighting the elements and sometimes the Indians or bandits or disgruntled homesteaders.

As the frontier closed, and defined ranches became the norm, the cowboy became an essential part of the cattle industry. He continued working for a low salary, as he does to this very day, despite the fact that his job involves great skill, considerable risk, long working hours, and rigorous weather conditions.

I only cowboyed on summer jobs, for as little as eighty-five dollars a month, and as much as one-hundred and fifty, until I became a doctor of veterinary medicine in 1956. But, I got to know a lot of full time cowboys. Many of these men were educated, either formally or informally because they were avid readers. Many had artistic ability especially in drawing, or in poetry. It is no coincidence that the largest poetry movement in America is the Cowboy Poetry movement, or that the largest art movement is Western Art.

Why They Do It!

If you ask them, some will explain that it is the outdoors that attracts them, and being close to nature. But, a telephone lineman works outdoors and a rafting guide is close to nature.

Some claim that they just like working with cattle. But, they could work on a dairy farm and make a better income.

No, cowboys – <u>real</u> cowboys – must work with horses. Some, as on the larger Southwestern outfits may be horseback all year. To the North, where the winters are more extreme, most of the riding is done during the warmer months and much of the winter may be spent feeding hay to the cattle.

But, on the vast majority of cattle ranches, horses are used sporadically to gather cattle, to move them, and during brandings or otherwise working cattle.

So, most cowboys today are part time cowboys, spending much of their time repairing fences, farming, and doing other routine agricultural tasks.

But, most of them still treasure their identity as cowboys. Why? Because of their pride as horsemen! That's the point of this chapter; to get the reader to understand that it is <u>the horse</u> that is the true identity of the American cowboy, just as it is in other lands. It is <u>the horse</u> that identifies the Argentine Gaucho from other agricultural workers, as it does the French Guardien, the Peruvian Chalon, the Hawaiian Paniolo, the Florida Cracker, the Nevada Buckeroo, the California Vaquero, the Texas Cowpuncher, the Australian Ringer or Bushman, and the Mexican Charro; they are all cowboys, united by the horse.

Just as the Medieval Knights, the horseman of the Middle Ages, adopted a code of "chivalry" (from the Latin word for horse) so has the cowboy culture developed a code of behavior which is interesting to contemplate and which is quite different from the Hollywood image.

"Riding For the Brand" refers to loyalty to one's employer, a concept quite at odds with the tendency of today's youth in high tech industry, to quit one job and jump to another repeatedly.

"Cowboy Ethics" includes the above, plus a powerful work ethic that does not insist upon coffee breaks, time and a half after eight hours of work, devious side benefits, or labor union rules. Real cowboys don't have labor unions.

The real cowboy culture has a code of integrity, of toughness, of courage in the face of adversity, of not whining or complaining, of suffering silently when injured that speaks of its frontier origins. It has become lost in most of modern American culture. It was the rule in our pioneer, seafaring, sharecropping, homesteading, enslaved, indentured, liberty cherishing, fundamental, nobility spurning past.

The cowboy ethical code is evident in the sport of rodeo wherein contestants <u>PAY</u> to compete, and only a few winners come out ahead financially, sharing the jackpot. And, considering the skills necessary and the physical risks involved, even the National Champions in rodeo earn a pittance compared to the wages paid mediocre big league ball players. Contestants traditionally help and advise their rivals.

How long this will continue is hard to predict as TV ratings, wealthy advertisers, and attendance receipts increasingly determine the future of the sport.

Millions of true horse lovers, including many who compete in Western horse show classes have no understanding of the true cowboy culture and its ethical code. That's why I included this chapter. That's why Western Art and Cowboy Poetry and Western Music Festivals (I'm not talking about today's Nashville "Country Music") are so immensely popular. They celebrate our frontier past. They reflect the values that made America what it is and that's got nothing to do with making a hero of a homicidal degenerate like Billy the Kid or a fictional hero like the Lone Ranger. Hi Yo, Silver! Away!

"The horse is the lowest common denominator in
cowboy poetry; it's what cowboying boils down to.
I guess there are some guys that ranch because they like cattle,
but I ranch because I want to work horseback. The horse
has been at the forefront of every piece
of cowboy poetry I've written.
Without him, there wouldn't be a piece."

–Joel Nelson, celebrated poet
Alpine, Texas

Help Wanted

"Highly skilled worker experienced with horses and cattle.
Must be able to ride expertly, including green colts,
rope efficiently, herd and doctor cattle,
castrate bulls, shoe horses, repair leather,
work long hours in a miserable climate.
Dangerous work. Often alone. Long way from town.
Will provide small salary,
shabby living quarters, no side benefits."
Who would accept such a job?

Someone who loved horses.

THE RIGORS OF COWBOY LIFE.

This may not be a profitable business, but one must consider the intangible benefits, such as the lifestyle one enjoys.

I'd never ride a bronc like that under a power line! Yes sir, I read where the electromagnetic field can cause cancer!

From my self-published book
Ranchin', Ropin', an' Doctorin'

Chapter

8

More on the Art Connection

I mentioned Eitan Beth-Halachmy earlier in this book. I also devoted a full chapter to this man in my previous book, **Natural Horsemanship Explained**. The respected senior Western horse trainer, Jack Brainard, who now resides in Tioga, Texas, told me that he believed Eitan to be the world's best living horseman. That's a supreme compliment. I believe Eitan is the best horseman I have known in my lifetime, but I haven't known as many as Jack Brainard.

Discussing the idea for this book with Eitan, he made some observations that I thought were very thoughtful and pertinent, and I will quote him:

"Horse trainers are craftsmen. Horsemen are artists: every person I know who is so involved with horses that they become a vital part of their lives, is an artist."

"Many people do not know how to define their talents."

"All people are born with similar abilities, but to very different degrees."

"Artistic talent is a prerequisite for great horsemanship."

Even the lone non-artistic horse lover I interviewed for this book, psychologist Cile Banks, verifies Eitan's last observation that "artistic ability is a prerequisite for great horsemanship." Cile's love for animals, her strong nurturing instinct, has made her exceptionally competent in shaping the behavior of foals, but she is, she admits, not a talented horseman when she is astride her horse. The artistry is missing.

Conversely, as an equine practitioner, I have had very successful trainers who were very effective on the horse's back, in the show ring, but I didn't want them nearby when I was treating one of their horses. Their presence made the horses harder to handle. They were agitated by the trainers presence. What I suspect here is that these people had the technical know how and perhaps the artistic ability to be winners in the show ring, but what was lacking was the nurturing instinct.

For example, I had one veterinary account, a barn filled with many Warmblood horses. The owner and trainer was an internationally successful horseshow competitor. I could not jeopardize our relationship by asking him not to hold his horses for me when I doctored them. So, instead I worked out a system with my assistants. Most of these were licensed veterinary technicians and most of them were women. The best one I ever had was a small middle-aged lady. She would ask the trainer to hold some equipment and she would diplomatically take the horse's lead rope from him. She would then discreetly lead the horse away from him. I would pretend to be occupied until I saw the patient relax and the wide-eyed anxiety subside before I approached to do whatever treatment was indicated.

This was a very common situation in my practice. These were very successful trainers in competitive disciplines. But, something was lacking.

They knew horses and knew them well, but that deep love was lacking. Trainers like these had no interest in *"Natural Horsemanship."* Most of them were men, but not all. There were a few women. In fact, the harshest, cruelest trainer I ever had in my practice was a woman, and she was a success in the show ring.

So gender does not guarantee the nurturing instinct. Nor does one have to be a genuine horse lover to be successful in the horse show arena.

Horse people who are reading this, please pay attention! Have you ever noticed how few of the leading clinicians in the Revolution in Horsemanship movement participate in horse shows? Do you believe that they lack the competence to show successfully? Or, is it that their profound love of horses makes them deplore some of the excesses that exist in the show horse industry?

The "soring" of Tennessee Walking Horses is probably the most extreme example of what I mean. However, I also find common practices within other breeds and disciplines deplorable. The excessive mouth contact seen in so many dressage classes is an example. Less obvious cruelty is seen in Western Pleasure and Reining events where the horse has learned to carry the head in an abnormally low position. As a veterinarian with over a half a century's experience in such matters, I understand how this causes excessive weight to be carried on the forehand, greatly increasing the stress upon the joints. This is one reason for the epidemic of premature forelimb lameness in such horses, to the benefit of the pharmaceutical companies who sell drugs to relieve the pain of osteoarthritis and other orthopedic disorders. The other reason is the widespread practice of putting horses into training at or even before they are two years of age. A two-year-old horse is an adolescent, and we demand of them Olympic caliber performance.

Horsemanship is an Art and a Science. Some master the Art. Some master the Science. This book is about the human qualities necessary to master both the Art <u>and</u> the Science.

Chapter

9

The Horse,
A Unique Creature

Only a dozen of the large mammals have been domesticated by man of the many hundreds with which early humans had contact. The Australian aborigine had only the dog. The South Americans had the dog, the llama, the alpaca and the guinea pig.

The primitive inhabitants of Europe and Asia had a diversity of species which were successfully domesticated. These were the dog, swine, sheep, goats, cattle, rabbits, the ass and the horse.

Undoubtedly, people tried to domesticate many other species, but for one reason or another, most were unsuitable.

The domestication of the horse unquestionably had the most profound effect upon civilization's advancement. Once humans began riding horses, which was probably about six thousand years ago, life changed dramatically for those people who domesticated them.

Wild horses had been a food source man for hundreds of thousands

years before he learned to ride and hitch them to chariots. Indeed, hunting by humans, as well as by canine and feline predators, may be the reason the horse disappeared from the plains of North America, the continent where the horse evolved. Sometime after the last ice age, about thirteen thousand years ago, more or less, the horse became extinct on the very continent where it had evolved millions of years earlier.

Of course, by that time the horse had long before migrated across the Bering land bridge into Asia. From there it spread across Europe and down through the Middle East into Africa, evolving as it migrated to better adapt to the varying habitats it encountered along the way. The modern horse, the ass, the onager, and the various species of zebra, therefore, all have common ancestry.

The dog was domesticated for many millennia before the horse, and on every continent was closely associated with stone-age man.

Humans and dogs are readily compatible. Both are hunters, both intelligent, highly sociable and omnivorous. The domestic dog's ancestor, the wolf, was simultaneously present in all areas inhabited by early man; the Americas, Eurasia, Africa, and, when primitive tribes migrated into Australia, their dogs went with them.

The dogs speed, endurance, keen sense of smell and pack hunting instinct complimented the human hunter's ingenuity and tool using ability. They made a formidable hunting team.

Other mammals were domesticated before horses, including the ass and cattle. Long before horses were used as draft animals, oxen served in that capacity.

However, once humans conceived of riding horses, something that began on the plains of Eurasia, they experienced factors which enabled them to spread their cultures, their genes, their art, and their technology as no other animal could. This is because of the horse's ability to transport people great distances and rapidly.

Thus, in warfare, in hunting, in exploration and in furthering a

nomadic existence, the horse gave man an enormous advantage over people forced to travel afoot. Mounted warriors easily subdued and dominated those people who had no horses.

We call the dog "Man's Best Friend" yet, domestication of the horse is achieved more readily than with other species, including the dog. Dogs, for example, if deprived of all human contact before twelve weeks of age suffer "failure of socialization" and do not make satisfactory domesticated animals.

On the other hand, horses, even completely wild horses that have never experienced any form of contact with human beings, can be "tamed" and "broke" to be safe and gentle domestic animals, completely accepting human dominance.

If this is true, and we now know that wild horses can be gentled and made safe in a few hours time, then the horse deserves the title of "Man's Best Friend," or at least should share it with the dog. Or, perhaps the horse should be called "Man's Best Servant." On the other hand, a servant can quit his or her job. So, perhaps the horse is "Man's Best Slave."

Even more astounding is that the horse is a prey species and in some respects may be regarded as the ultimate prey species. This is because unlike so many prey species which are equipped with formidable weaponry such as horns or tusks, the horse defends itself with flight. Flight is the horse's primary defense. This is because it is the most effective defense for an herbivorous prey which lives on open plains that are inhabited by a variety of predatory animals of the dog and cat family.

For example, among the species preyed upon and eaten by African lions are Cape Buffalo, rhinoceros, hippopotamus, and elephant. Witness the weaponry these creatures possess.

So, isn't it amazing that this flighty, timid prey species, the horse, can bond with an aggressive, predatory species, the human, more quickly than any other animal? If this is done without coercion, which only

encourages the flight response, but instead using gentle, persuasive methods which encourage subordination so that the horse regards the human as a herd leader, the process can be done in an average of three hours. Of course, this is only the beginning of the training process. But, at least the initial taming and bonding and establishing the human as the herd leader can be done in only a few hours time, if appropriate methods are used. Even older feral stallions can be gentled by these means to become acceptable domestic animals.

Who would have believed a few decades ago that half a dozen American prisons are having captured mustangs assigned to inmates who then, using Natural Horsemanship methods, turn those terrified wild animals into gentle and trusting creatures in only a few hours. It's just a question of knowing how. There is hope.

It must be explained that technically the "wild" horses are actually "feral." That is, even though they have had no previous human contact, they have descended from horses that were once domesticated horses. This does not diminish the uniqueness of the human-animal relationship. Rather, it increases the relationship because domestic horses have been selectively bred for greater athleticism, response time, speed, and agility than is required in nature. A Thoroughbred race horses can easily outrun any actual wild horse. The wild horse needs only enough speed and endurance to outrun the big cats or wolves. So, feral domestic horses can actually be more challenging than truly wild horses.

Somewhere, long, long ago, a stone-age boy clad in animal skins, was fascinated by the wild horses that provided a part of his clan's diet. He observed them and drew pictures of them on the cave walls.

Then, one day, he captured a newborn foal, handled it, and caressed it. The foal remembered him and would periodically return to visit, because it knew him and was strongly bonded to him.

When the foal was nearly grown, the boy climbed up onto its back, and the history of mankind changed forever with that act.

This book is not a book of fiction, except for the story above. Yet, I know it actually happened. It had to have happened. The true stories in this book make that event understandable.

Over the course of my long lifetime, I have often changed my mind as to what is the most important of all human qualities. At various times I thought it was courage, or a logical mind, or open mindedness, or high intelligence. Now, finally, I realize that the most precious of all human qualities is kindness. If we were all kind and that kindness extended to all living things in so far as is possible, most of the world's problems would be resolved. In this book I think I have conclusively shown that creative artistic talent is an essential quality in those persons who are genuine horse lovers. They are also kind, and this kindness almost always extends to other animals as well as horses.

Now, all we have to do is be just as kind to our fellow humans, at least to all those who are not unkind to us.

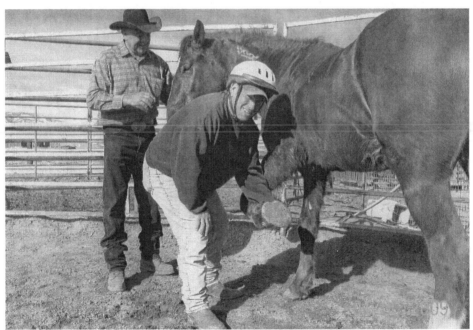

Here is instructor and program director Hank Curry (black hat)

An inmate from the Nevada State Prison System with the mustang he trained.

Epilog

Afterthoughts

Because I am a doctor of veterinary medicine, schooled in a scientific discipline, I have for most of my life concentrated on the scientific aspect of the Art and Science of Horsemanship. Understanding the physiological and neurological basis for equine behavior was paramount to me, even though I was cognizant of the artistic flair possessed by most devoted horsemen.

However, in recent years, as I've aged and acquired more wisdom, I have become increasingly aware of the artistry. Nowhere that I've been is more emphasis placed upon art of horsemanship than in the Hispanic cultures. I say this while acknowledging that too often within the Hispanic cultures, as in all others, the science of horsemanship is not adequately recognized. As a result brutal inhumane methods too often are involved in the training and use of horses.

Never-the-less, the artistry typical of Hispanic horsemanship is something other cultures, including the American culture with its emphasis upon speed, should look at.

At Ecumad, the exposition featuring the Iberian breeds in Madrid (Andalusian, Lusitano, and the Spanish Arabian horse) I watched a reining class. The riders were dressed in a manner that explains the origins of American cowboy apparel; broad brimmed hats, chaps, and boots. The

horses, calmly and gracefully did slide stops, spins, and lead changes. There was no emphasis upon speed. It was all about grace, smoothness, and perfection in movement.

In Portugal, and in Brazil, I watched bullfighting horses. These Lusitanos are not put in the bull ring until completely trained at seven or eight years of age. They are too valuable to risk injury. I am not an advocate of bullfighting, not even Portugese bullfighting wherein the bull is not killed, but how I admire the horses and the extremely skilled riders. The deft and graceful movements of the horse, evading the horns of the bulls, are a spectacle to behold.

At the Charro Finals in Morelia, Mexico one year I watched team roping, and horse roping. Speed did not matter. It was the grace and coordination and accuracy of the ropers that counted. The emphasis was on elegance, not time.

America has made the greatest contribution to the horse in human history. We began a Revolution in Horsemanship which has spread an understanding of the science of equine behavior, and eliminated much of the ignorant and inhumane techniques that mankind has inflicted upon horses since we first domesticated them.

On the other hand, we need to slow down. We start our horses too soon, work them too hard, and break them down too early in life. This profits we veterinarians and the pharmaceutical industry, but is it right?

Those of us involved with horses need to learn from each other and to respect one another.

The posture in the saddle top Hispanic horsemen assume is to be admired. I realize that there is a cultural aspect to this. It is seen in the movements of Flamenco. It is displayed in the carriage and posturing of the matador. It exists to a limited extent in the United States thanks to the revival of colonial California Vaquero horsemanship.

Let us combine American know how, with the patience and grace of Hispanic horsemanship, with the discipline and exactness of classical

European horsemanship. By combining art and science, the virtues of the true horse lover, not only will our horsemanship be benefitted, but so will the welfare of our best friend and servant, the horse.